THE
CHINESE BRUSH
PAINTING
HANDBOOK

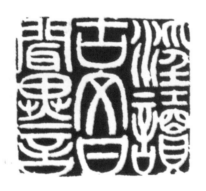

THE
CHINESE BRUSH
PAINTING
HANDBOOK

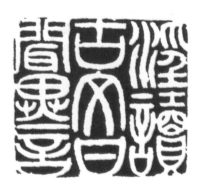

Edited by Viv Foster

BARRON'S

A QUANTUM BOOK

First edition for North America published in 2006
by Barron's Educational Series, Inc.

All inquiries should be addressed to:
Barron's Educational Series, Inc.
250 Wireless Boulevard
Hauppauge, NY 11788
www.barronseduc.com

Library of Congress Control Number 2005925461

ISBN-13: 978-0-7641-5911-4
ISBN-10: 0-7641-5911-9

QUMCBPH

Conceived, designed, and produced by
Quantum Publishing Ltd.
The Old Brewery
6 Blundell Street
London N7 9BH UK

Manufactured in Singapore by Universal Graphics Pte Ltd.

Printed in China by CT Printing Ltd.
9 8 7 6 5 4 3 2 1

Contents

Introduction

Chinese brush painting is an ideal subject to study. It gives the complete beginner a sense of achievement and the more experienced and serious student endless creative possibilities to explore.

The Chinese have had a great influence on the world of art, not least because they invented paper. Their stunning creations, both on silk and paper, have fascinated generations of admirers in the West. But today, many of us are either unaware of Chinese painting techniques, or know the basics and want to learn more.

This book aims to enlighten students, whether beginner or more experienced, to the fascinating and stimulating world of Chinese brush painting. It contains all the information you will need in order to start painting in this style, as well as providing beautiful step-by-step

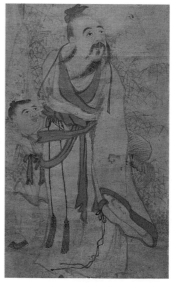

ABOVE *Part of a large traditional figure painting scroll by Zhu Zhensheng showing a scholar and his servant (carrying an instrument).*

TOP *The contrast in style and technique between the picture on the right and these currants shows how much room there is for personal style to develop.*

6

projects for all experience levels.

As you begin to discover more about this ancient art form, you will find that the beauty of many Chinese paintings is down to their simplicity; but, in the majority of cases, this simplicity is deceptive, as many of these works contain hidden meanings and symbols.

The distinguished scholars in China's ancient past made sure that poetry and philosophy, fine calligraphy, and harmony all played important roles in the pictures they handed down to future generations. We have inherited their wonderful gift and can begin to learn how to produce successful pictures of our own, while remaining true to the principles of the past.

Around 2,500 years ago, an artist named Xie He wrote down six general rules by which artists should judge their work. Xie He wrote each principle in just a few characters. The interpretations of these characters have varied widely over the years but here is a flavor of them:

First Principle *Rhythmic Vitality* A picture should be inspired and have a life of its own. It should have a spiritual element.

Second Principle *Anatomical Structure* This stresses the importance of the use of the brush in the drawing of the lines of a picture.

Third Principle *Depicting the Likeness of the Subject* The drawing should be correct according to the nature of the subject.

Fourth Principle *Color and its relevance* The color in a picture should be true to the nature of the subject.

Fifth Principle *Composition and the Correct Division of Space* When planning a picture, the artist should observe the proper grouping of objects according to their importance within that picture.

Sixth Principle *Copying the Masters* Paintings should be guided and informed by the work of acknowledged artists of the past.

This book is written with these six principles very much in mind. It teaches you the basics of this unique style of painting and, for more experienced students, provides advanced techniques and explanations. Above all, it aims to open your eyes to the special nature of Chinese brush painting.

It is interesting to note that the Chinese traditionally meditate before commencing a painting. They settle their minds and think of the picture about to be painted. We have no tradition of this in the West but, with many of us living such hectic lives, maybe we could benefit from this considered and harmonious approach to painting.

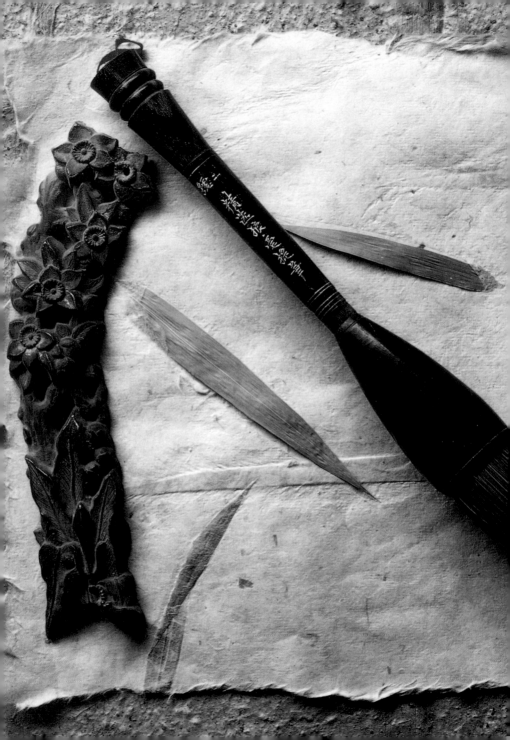

Materials and Equipment

The materials of Chinese painting are unique. A great deal of the charm of Chinese art relies on their singular properties, so try to use authentic materials from the start, following the guidelines given here, and choose the best quality you can afford. It is worth spending time learning about the materials and equipment used to produce Chinese painting, as without a basic understanding you cannot hope to achieve successful works. Your materials will become your "best friends" as you work through the book, so it is crucial that you become acquainted. This chapter looks at brushes, paper, ink, stone, colors, and waterpots, providing you with the information you need to know before you begin painting.

Brushes

The Chinese brush is still made today in the same way as it was made some 3,000 years ago. That is with natural hairs, collected together, and then glued into a hollow bamboo handle.

A man named Meng Tien is said to have invented the brush. He lived about 4,000 years ago and may have gotten the idea from people who lived before that.

The hairs used to make the brush can vary. Sable, rabbit, wolf, squirrel, goat, and horse are used, to name but a few. Sometimes two very different hair types are used together, giving the artist the opportunity to create differing marks and to experiment with ink loading.

The handles of the brushes have a little loop at the top. This is for hanging the brush up after use, to allow any excess water to drip off the tip. If the water were allowed to settle around the neck of the brush it would dissolve the glue, thus destroying the brush.

When beginning to paint it is a good idea to purchase four basic brushes. The "orchid bamboo" brush is the first. It has sable hair and is easy to control. Then you will need a goat-hair brush. This brush has soft white hair and is often called a "white cloud." A fine line brush is very useful if you want to "draw" with the brush. Finally, a hake brush, which has wide, flat hair, is very good if you want to put washes on finished pictures.

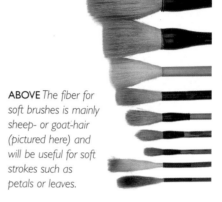

ABOVE *The fiber for soft brushes is mainly sheep- or goat-hair (pictured here) and will be useful for soft strokes such as petals or leaves.*

New brushes come with an alum coating on the ferrules. This is to keep the brush in good condition while it is packaged and sent for sale. To ensure that your new brushes are in perfect condition to paint with, you will need to put them in water for about five minutes and then squeeze the tip in your fingers, making sure that the hairs are all soft. Throw away the lid—this will prevent you from trying to put it back on the brush where it would push back the hair and damage the ferrule.

To hold a Chinese brush correctly, pretend that you are holding chopsticks. The thumb and index finger grip the handle and the middle should be

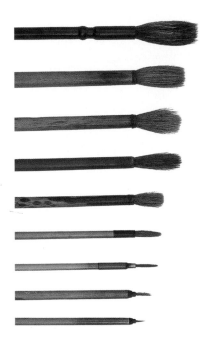

LEFT *Firm and flexible brushes giving a good point are usually wolf-hair or similar.*

The brush should be held lightly enough to allow free and easy movement but firm enough that it is always under your control. For painting vivacious strokes, the wrist should be flexible, and for "drawing" lines, it should be firm. The quality of your paintings will depend on how you hold the brush and how you use it. The passageway from the artist's mind and heart onto paper, through the arm and brush, must therefore feel comfortable and positive. Compare the feeling of holding a pencil in the Western fashion—tightly and at an angle. Now hold your Chinese brush, lightly, with the elbow and arm up, and the tip of the brush touching the paper vertically. A good Chinese artist will always grip the brush high up on the handle, giving him/her maximum freedom.

Loading the brush with ink is particularly important, because the Xuan paper is a little like blotting paper

positioned right next to the index finger. I always know when a student is not holding the brush correctly because I can't see two fingers holding the handle. The ring finger and little finger should lie behind the handle but not be in contact with it. If you can imagine that you are holding an egg in the palm of your hand, and do not want to crush it, then you will have a hollow palm that is ideal for painting.

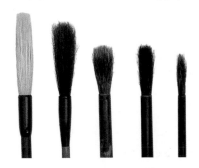

RIGHT *Stiff brushes are used for figures and landscapes. The hair is often from a horse or pig.*

to paint on. The ink, once you have made it, will be ideal to practice with. Begin by wetting your brush in clear water. Wipe the brush on the edge of the container to get rid of the excess water. Now dip the tip of the brush into the ink and watch it rise up the brush. As it rises, the ink will become diluted to some extent as it mixes with the water in the brush. Wipe the tip again, on the edge of the inkstone (see page 17). This will get rid of the excess ink and leave the brush ready to paint with.

Strokes are made to differ by adjusting the pressure with which you apply the brush to the paper. In short, if you want to achieve a thicker line, simply apply the tip of the brush to the paper a little more heavily. It is a good idea to find a piece of old newspaper and begin to practice on that. (This process has the added benefit of allowing you to relax and learn the best possible way—by making mistakes.)

Holding the brush vertically to the page, begin by making a line all the way across it, followed by another and yet another. Masters of the art still do this before they begin to paint, to steady their strokes and their hand. If you can describe a circle in the air, with your brushstroke being the lower part of the circle, then you can begin to breathe in a positive fashion too. Breathe in as you get to the end of the stroke and lift into the air, then hold that breath until you arrive at the right side of the paper. Breathe out as you paint your line. It is best to paint very slowly to begin with.

Once you have done several plain lines, begin to exert a little more pressure on the brush, remembering to hold it vertically all the time. Finally, press quite hard, trying to use the entire ferrule, so that your lines are very wide. Again, the brush must be held vertically, and continue the breathing pattern.

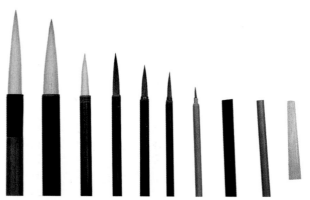

LEFT *New brushes are protected by an alum solution to make a stiff point. This must be washed out before use. The bamboo or plastic covers shown on the right must be discarded; trying to replace them will damage the brush. For protection when carrying the brushes around it is best to use a split bamboo brush-roll or a flexible table mat.*

Paper

Paper has been in use for around 2,000 years. Some modern papers are still very similar to those first ones. Because paper was so highly regarded emperors had special buildings as paper stores.

Before the Chinese invented paper, they made silk. The earliest paintings were therefore executed in clear outlines on a woven silk. Examples of these creations are still available to study today.

In 105 C.E. a man called Cai Lun started matting vegetable fibers together to make a flexible, thin material. He was a court official of the Han Dynasty and had the time to try all sorts of different fibers. Felt cloth was made at that time from animal fibers, and Cai Lun was probably trying to produce a fabric of sorts. He experimented with tree bark, hemp, flax, fishnetting, and rags, and eventually made the first paper. It must have been fairly rough, but soon the process was being exported to places across China, where a variety of people continued Cai Lun's experiments, trying out fibers

from a variety of sources, including bamboo, mulberry bark, and cotton rag. We in the West often refer to Chinese paper as "rice paper," but this is a misleading name. It has its roots in the fact that all paper used to be made with rice glue, which is no longer the case.

The tradition of papermaking continues in China to this day, with the country's industry centered in Xuan. This town has a river running close by in which tree trunks are soaked, often for years. The sandalwood tree is particularly important in papermaking and a lot of this wood is used. Once the wood is soggy it is pulped into fibers and size (glue) is added. The pulp

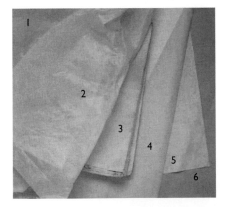

1	*Pi zhi*	*absorbent mulberry bark paper*
2	*te jing pi*	*best quality Xuanzhi*
3	*dan xuan*	*single-ply absorbent Xuanzhi or rice paper*
4	*jian qian zhi*	*semi-sized with gold leaf flakes*
5	*jian qian zhi*	*as 4 but a different color*
6	*yuan shu zhi*	*grass paper*

is poured into large vats and then a papermaker uses a large, finely grained mesh screen to scoop each sheet of paper out of the vat. This is a very skilled job and is a crucial stage in the papermaking process. Once the new sheet of paper has dripped for a while, it is picked off the mesh and flung against a hot wall. As it dries it is brushed flat with a large, wide brush and then it is peeled off the wall and placed in a pile with all the other sheets. Those who have painted on Xuan paper know how easily wet paper tears. Try wetting a brush and drawing a line across your Chinese paper with it. Pick the paper up and tear it across the water line. It will fall apart easily.

The absorbency of paper is governed by the amount of size, or glue, added to the fiber mixture. Freestyle painting is usually done on very absorbent paper. Meticulous work is better suited to non-absorbent paper or prepared silk.

The thickness of the paper is described as "ply." A single-ply paper is very thin, a double-ply is slightly thicker, and three-ply is the heaviest. Meticulous papers can be as thin as onion skin and may have the added bonus of a sprinkling of glitter across the surface. This is produced by alum crystals, which are sprayed on to help fix the painting to the surface as well as for decorative reasons.

The types of mark you will be able to make are as much dictated by the choice of paper as they are by the load of your brush. Experiment with the main types of paper (outlined on the opposite page) and note the effects achieved by loading your brush with small and large amounts of ink. It takes some practice to load the brush properly, and some experimenting with different kinds of paper, before you are able to accurately judge what effects you will achieve on the four main types of paper.

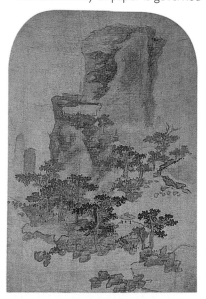

LEFT *Traditional landscape of the early Qing dynasty on silk.*

OPPOSITE PAGE *Various papers are shown with the same brushstrokes. An effort was made to apply the same pressure and use the same amount of ink in the brush for all examples.*

THE FOUR MAIN TYPES OF PAPER

Moon Palace, or practice paper, is from Taiwan or Japan and is machine made. It is very white with one smooth side and although very cheap and useful as practice paper, it is bland and without character. It can be purchased in rolls 12 inches (300 mm), 18 inches (450 mm), and 24 inches (600 mm) wide or in A3 sheets. It is classed as semiabsorbent.

The second type can also be classified as practice paper and is usually made of grass- (mao bian) or wood-pulp. Again it has one very smooth side but is a pleasing yellow color. Some Korean and Yuan shu papers also come within this color range. They are not quite so absorbent and are available as sheets.

The Yuan shu paper is more difficult to mount than other types.

The third type is Xuan paper. This is handmade and a lovely creamy color. It comes in different absorbencies and varying thicknesses; single, double, and triple thicknesses give different effects. Some of this paper has more 'blemishes' in it than other types. The most common version is unsized, or absorbent.

The last paper is sized Xuanzhi. This is thick and is not so easily obtainable. "Sized" means that it is non-absorbent— any line painted on this variety does not spread into the paper. You can buy this paper as single large sheets, or in a roll of 10 sheets 6 feet (1,800 mm) long.

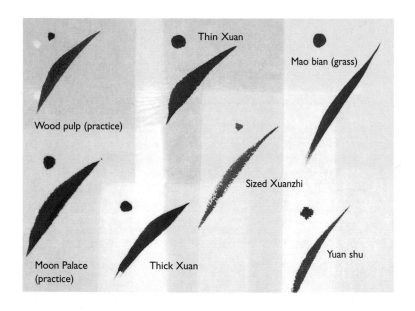

Thin Xuan

Mao bian (grass)

Wood pulp (practice)

Sized Xuanzhi

Moon Palace
(practice)

Thick Xuan

Yuan shu

Ink Stick

Ink sticks are often beautifully decorated and many are collected purely for their appearance. In the past they contained ground jade or pearls, and sticks from a particular maker were especially prized. Their value was given as ten times that of gold!

An ink stick with a sheen or a matt finish should be chosen, rather than a glossy one and the weight of the stick should be light for its size. There are several different colors—blue-black, brown-black, and a true black, depending on the part of the pine tree that has been used.

LEFT *Impression from a bronze seal saying, 'Five kinds of color'*

The sticks are made from pine- or oil-soot and resin, and it is the quantity of resin that makes the sticks so variable. Take care that the stick is not left in contact with a wet inkstone—the resin will adhere to the stone and may be damaged on separation. Get into the habit of drying the end of the stick on a piece of tissue. You should store an ink stick in a dark, cool place. The resin tends to deteriorate in time and an old ink stick may well crack and flake. A fresh stick will have a pleasant smell, often of sandalwood or pine.

When grinding the ink, make enough for your painting but not too much so that it is left to dry. The ink stick should be used from one end only, held vertically, rather than sloping. Do not use more water than you need; to make thick, black ink takes 200 revolutions for a teaspoonful of water!

When grinding the ink keep in mind its eventual use; whether it needs to be very black, or light gray, dry, or wet. There are five main descriptions of the colors—burnt ink, thick ink, dry light ink, light ink, and wet ink ("Five kinds of color"). Mixing any two or three of these together will create differing effects on the paper and the study of all the combinations could last a lifetime.

Although many people use the bottles of liquid ink available today, ink sticks are still considered to be superior. The benefit of having to grind your ink is the time that the process involves. Because grinding takes time, it will allow you space to collect your thoughts, and time to think about the picture to be painted.

Colored sticks are ground in the same way as the ink stick, although they should not be ground on the same stone. They are made exactly the same way as the ink stick but natural pigments are mixed with the glue instead of soot.

Inkstone

The freshness of ink is of the utmost importance. Grinding the ink with due regard to the purpose for which it will be used is said to produce better work. The process of grinding the ink also prepares the mind and the wrist of the painter for the first brushstroke. A time for beautiful thoughts!

The inkstone is the piece of equipment essential for grinding the ink stick on. Making sooty black ink for calligraphy, or any other painting, should be a relaxing and fulfilling occupation.

Inkstones are highly prized items and can be very ancient and very valuable. Stones are often passed down through the generations as treasured heirlooms, especially if the artists who have used them are well known. They can be carved from jade, or made from ceramics and be beautifully decorated. The most common stone, however, is made from smooth, nonporous slate. It should be chosen with care to ensure that the grinding surface is smooth and level. A gritty, uneven surface will ruin

your stick and produce inferior ink. All sorts of shapes are available, but the easiest to use are circular or rectangular with a lid to keep the ink fresh.

Begin by dripping a few drops of water onto the surface of the stone. A teaspoon of water should be sufficient initially. Now grind the inkstone into the water by holding it upright and moving it in circles. A good thick ink will leave a trail behind the stick and it should not take too long—about 200 revolutions should be adequate. Always make enough ink to complete the painting you intend to do and then wash out the stone at the end of the day. Dry it and make fresh ink the next time you intend to paint.

The ink stick must be dried after grinding ink. If it is left lying on any surface it will dry and stick firmly to that surface because, as explained earlier, it is made with glue. A wet ink stick will also crack as it dries, so just blot the end thoroughly on a piece of tissue each time and it should last for years.

LEFT *Various inkstones, ink sticks, and good-quality bottled ink all should be capable of producing fine ink without damaging brushes.*

Colors

Chinese paintings are often carried out solely in shades of black giving a monochrome effect. In landscapes and some early styles the color was used very lightly and sparingly, with the ink giving the structure of the painting. Adding a red seal is called "adding an eye to a dragon."

However, many artists enjoy using color (also called paints and pigments) and in Chinese painting this involves natural materials (although some substitutes are now used). Some of the modern freestyle painting shows a much brighter and more dominant use of color where the structure of the subject is formed by colored pigments. There is little point, however, in using too much pigment as this will cause problems when mounting the work.

Chinese brush painting is basically a watercolor technique, exploiting the transparency and translucency of the paints that are obtained from mineral or vegetable sources. Western watercolors can be used, although they tend to contain additives and some colors do not soak into the paper properly.

BELOW *From right to left—Teppachi colors in porcelain pans, Chinese granules, which are packed in small neat boxes, and Chinese tube colors. Also shown are a typical chrysanthemum palette and Western stacking dishes, used for mixing colors.*

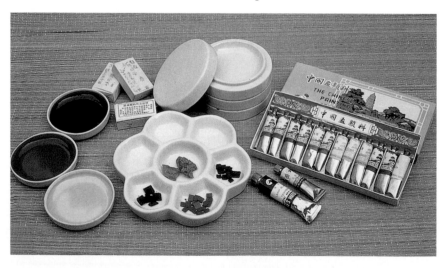

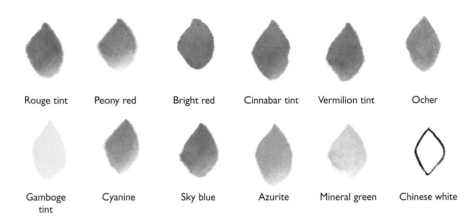

| Rouge tint | Peony red | Bright red | Cinnabar tint | Vermilion tint | Ocher |

| Gamboge tint | Cyanine | Sky blue | Azurite | Mineral green | Chinese white |

Although some of the traditional Chinese colors are very hard to obtain, colored inks should not be used for Chinese painting techniques.

The Eastern paints, which are available in stores, vary in quality, as do the Western versions. If buying a set of tubes you should look for Chinese Painting Colors. However, if in doubt, use the price of the paint as an indication of quality—in the case of Chinese paints, it's a reliable method. White gouache may be used sparingly for highlights to eyes, etc. It is sometimes used, again for highlighting, in the Lingnan style of painting.

Flake colors are obtainable in some Chinese shops and by mail order. These are small pieces of color: bright red, rough red, dark red, indigo, sky blue, burnt sienna, vermilion, peony, crimson—the last two being the most expensive. There is also rattan yellow,

ABOVE *These are small tubes and make a good starter set with traditional colors, also known as Chinese Painting Colors.*

made from a poisonous plant, and this is in a solid block over which you wipe your brush to obtain the color. The flakes can be placed in small dishes, either a Chinese version (such as a small, handleless cup), or a set of stacking dishes that many Western artists will already have. To release the color quickly pour warm water onto the flakes.

Other Chinese mineral pigments come in powder form that has to be mixed with gum, and is therefore not so popular. The most convenient way to obtain these beautiful stone greens and blues is to buy tubes.

Japanese colors in porcelain dishes are another alternative. There are 14 colors that differ slightly from their

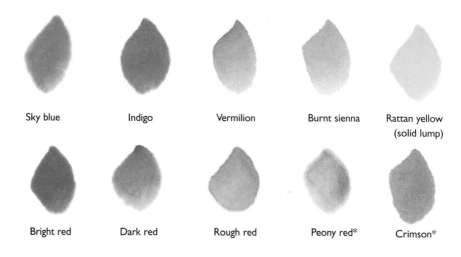

Sky blue	Indigo	Vermilion	Burnt sienna	Rattan yellow (solid lump)
Bright red	Dark red	Rough red	Peony red*	Crimson*

Chinese counterparts, but are a good substitute and convenient to use. To darken or make a color less bright, black is often added, usually black ink. Sometimes, however, a particular pigment will react with the ink and granulation will occur. This can be avoided by using black paint instead but it will give a more matt appearance. Black should never be added to flower colors, nor should white be added to leaf and branch colors.

Colored ink sticks are available in sets. These are mainly used for calligraphy and as each color requires a different inkstone, are less practical for painting.

Ink sticks based on oil of lacquer soot have a warm (and therefore

ABOVE *Chinese granules, also called flake colors, are sold in small, wrapped boxes from special outlets. Place the small pieces of pigment in a dish and add water to use.*

*(*more expensive than the other colors)*

blacker) appearance on white rice paper that is preferable for flower or bird painting; those based on pine soot give a softer, colder effect more suitable for landscape painting.

PAINTING BLANKET

Painting is always carried out on a thick, white felt or blanket. This is because the Xuan paper is so thin that it would adhere to any other surface. It is perfectly possible to use

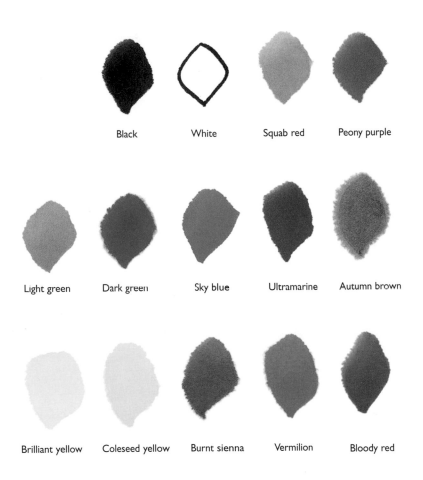

Black — White — Squab red — Peony purple

Light green — Dark green — Sky blue — Ultramarine — Autumn brown

Brilliant yellow — Coleseed yellow — Burnt sienna — Vermilion — Bloody red

an old blanket, cut to around 1 square yard (1 meter square). As much of the brush work is calligraphic, or "written," the painting surface is usually on the horizontal to facillitate the expression and spirit of the strokes.

ABOVE *There are 14 Japanese Teppachi colors sold in porcelain dishes. While these are not necessarily traditional Chinese colors, they are easy to use and readily available.*

Palettes and Water Pots

All the equipment traditionally used in the past, formed part of the "scholar's desk." Some were simple and cheap; others were of great value. Today these items are collected, both by artists and nonpainters alike.

WATER POTS

These can be anything from a yogurt container or jam jar to an ornate porcelain container. It is best to use two pots so that you always have clean water on hand. A small salt spoon or something similar can be used with the water pot to ladle water onto the inkstone.

PALETTE

There are several traditional patterns of palette. Some are called chrysanthemum dishes; others incorporate a similar design with a Yin and Yang water pot. While these are very pleasant to use, a Western palette or a plain white plate can be just as good, although on a flat plate the colors may tend to flow together. If using a larger amount of ink or color, as a wash for example, then the plate will be useful. If larger quantities of liquid are required, use a plain compartmented plate, which has much larger segments. Department stores are a good source for these.

OTHER ACCESSORIES

Brush Rests, Brush Pots, and Hangers
These are used during painting so that the wet brushes do not roll around the table and spoil either the painting or any spare paper. They are made from many materials—wood, stone, metal, or porcelain. The designs are often traditional, featuring mountains, dragons, and bamboo. The hangers and brush pots are used for storing the brushes when not in use. The pots are usually ceramic or wood, but sometimes metal. Again, bamboo is a favorite for material and for decoration. The hangers are invariably wooden.
Seals and Seal Paste
After you have been painting in the

LEFT *Water pots and droppers come in a wide variety of styles and materials, which has made them highly collectable by artists and nonartists alike.*

LEFT *Two contrasting designs of wooden brush hanger. The lefthand version can hold six to ten brushes. On the right a "dragon pine tree" that holds ten brushes of varying length.*

Chinese way for a short while, you will want to own some seals. These are used to sign your name or add a poetic idea or dedication to enhance the meaning of the image.

Seals are made with materials that can support fine carving techniques. They are imprinted with a bright red paste derived from the mineral known as cinnabar.

Artists' seals are different from those you can buy on every street corner in China. Painting seals have to be specially carved by an expert.

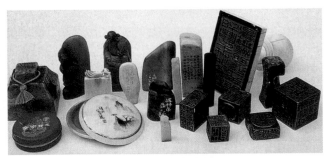

BELOW *Brush pots and rests of various sizes*

ABOVE *Seals can be made of stone, bronze, ivory, horn, and jade and may incorporate either the signature of the artist or a studio name, a poem, or a saying.*

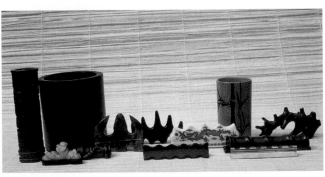

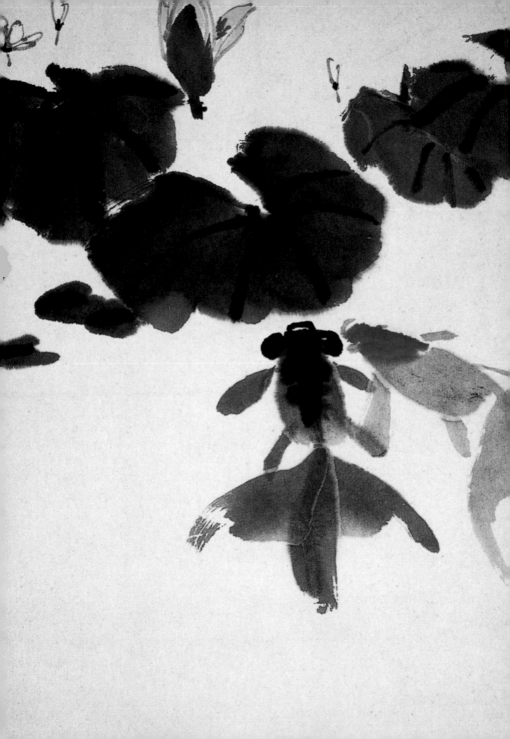

Getting Started

Before starting to paint you need to think about
the picture you are going to produce. Very often
this is done while you grind your ink. A more
peacful, focused mind will help your
concentration. A Chinese brush painting is
created using lines and dots, marks made on the
paper to produce a likeness or impression of
plants and animals, mountains and skies, fish and
insects. The painting is based on the pictorial
calligraphy strokes developed long ago and is
therefore often said to be "written" rather than
painted, and "read" rather than seen.

The Influence of Calligraphy

If you have been enchanted by the magic of traditional Chinese painting, you probably want to begin producing your own pictures as soon as possible. However, there are certain fundamental techniques to master first.

Initially, you need to learn how to use the special Chinese brush. The best way to learn this is to practice some Chinese calligraphy.

Traditional Chinese painting and calligraphy have their roots in the pictorial representations of objects that were first incised onto bone, shell, and bronze. As the need for increasingly complicated modes of expression developed, the symbols could no longer be related to objects, and purely abstract forms were introduced. There is a close connection between calligraphy and painting. The twin arts share the same basic materials of brush, paper, and ink, and the skillful use of the brush is the most important factor in both of them. A connection is

also maintained through the calligraphic inscriptions that are an essential part of many paintings.

The first and most important lesson is how to hold the brush (see right). This may seem difficult at first, but it is essential to practice until it is comfortable, because you cannot do Chinese painting without the correct finger positions.

BELOW *Many Chinese artists are also well-known calligraphers. This calligraphy passage in li shu style, by the famous Qing dynasty artist Zhong Ban Qiao, shows strength and artistic balance in the brushstrokes.*

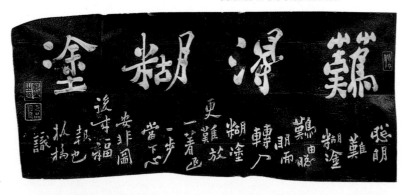

HOLDING THE BRUSH

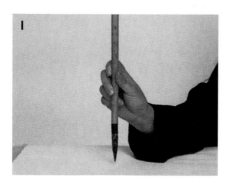

1 Hold the shaft of the brush between the thumb and the first and middle fingers. Tuck the fourth and fifth fingers neatly in behind. The palm of the hand should form a hollow in which you could hold an egg. Begin by sitting with the elbow resting on the table and the wrist cocked. Hold the brush halfway up the shaft and at right angles to the table.

2 The hold is always the same, whatever the size of brush. What can be varied is the place where you hold the shaft, and the position of your arm. The artist is still sitting, but the fingers are slightly higher up the shaft and the arm is off the table.

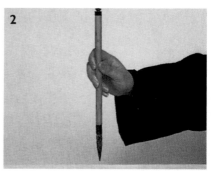

3 The maximum freedom is gained when you are standing up. Then you can use the entire arm from the shoulder and will be in the best position to execute wrist and elbow maneuvers (see the Orchid and Wisteria projects on pages 50-53 and 76-79 respectively) The brush is held near the end of the shaft.

BASIC STROKE PRINCIPLES

Three forms of calligraphy will help you practice your painting strokes. These examples all use the character *an*, meaning "peace." Practice them in the order shown, on newsprint or grass paper.

I Copy this *zhuan shu* character to learn the most common drawing stroke: the "center brush." Hold the shaft at right angles to the paper, keep the tip in the center of the stroke. Stroke width should be constant throughout. The center brush stroke is fundamental to calligraphy and painting. Performing it correctly will give you control of the brush.

BELOW *Many people in China enjoy practicing calligraphy as a hobby. Stone rubbings from ancient monuments and books of reproductions serve as examples.*

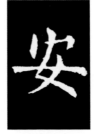

2 Chinese characters are based on a uniform structural size, however many strokes they contain. This gives them a balance, proportion, and elegance that is especially noticeable in the *kai shu* form. It is also done with a center brush, but involves changes of movement, thick and thin strokes, and careful structuring. This is the most useful style for learning the full range of basic strokes, and the "fall" example (right) gives you detailed instructions for it.

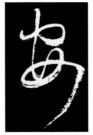

3 The flexibility of the brush is most fully exploited in the exuberant *cao shu* style. This is based on a *zhuanbi* "turning brush" in which the angle and direction constantly change in a continuous flowing movement. When the angle of the brush to the paper is at its lowest extreme, it is known as *cefeng* "side brush" and *cao shu* needs both center and side brush techniques.

FALL

This project, in the kal shu style, is based on the character for fall. It will give you a good foundation for all future painting, because it incorporates all the main painting strokes, showing you brush movement, pressure and control.

Cut a piece of grass paper or newsprint into a 4 inch (10 cm) square. Trace the pattern shown here in red. The aim is to achieve a balanced structure with the parts equally disposed about horizontal and vertical axes.

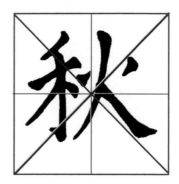

The numbers on the illustration below show the stroke order. The classic way to write is from top to bottom, and from left to right. It is important to follow this order exactly. Inside each stroke outline, numbers, and arrows indicate the direction of the stroke. This diagram should be read in conjunction with the step-by-step photographs that follow.

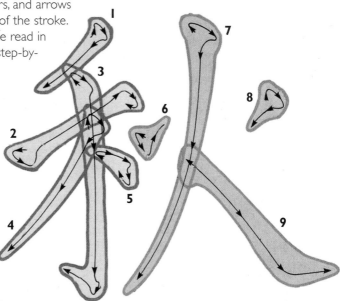

29

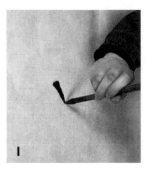

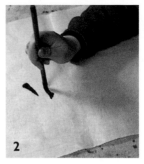

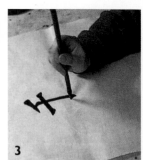

1 Begin at **1**, moving toward the top of the stroke. **2** Press down, coming back on the stroke. **3** Continue in a straight line. **4** Gently lift the brush off the paper.

2 **1** Tuck the end in. **2** Push down hard, then straighten the brush. **3** Gently release the pressure. **4** Push down gently and tuck the end in to finish.

3 **1** and **2** Tuck the end in. **3** Make a strong, straight stroke, pushing down hard at the end. **4**, **5**, and **6** Gently curve to the right, then go back on yourself, lifting up to the point of the brush at the end.

4 The stroke comes to a very fine point.

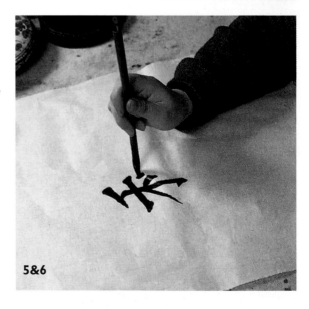

5&6 These two are dots. They are similar in execution, but follow a different direction of movement (see diagram.)

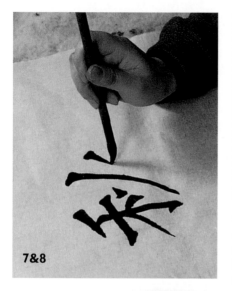

7&8

An important feature of many strokes in both calligraphy and painting is known as "tucking the end in." This involves starting the stroke by going a little way in the opposite direction to the one where you want the stroke to go. It gives a good solid shape to the stroke beginning. This may also be done at the end of a stroke.

7&8 **Stroke 7**: **1** and **2** Tuck the end in. **3**, **4**, and **5** Make a strong controlled stroke lifting at the end.
Stroke 8 is a dot, starting from the same angle as stroke **7**.

9 The final stroke is one of the most difficult. **1** Tuck in the end. **2** Press down firmly in the direction of the arrow. **3** Increase the pressure and change slightly to a side brush. **4** Lift gently.

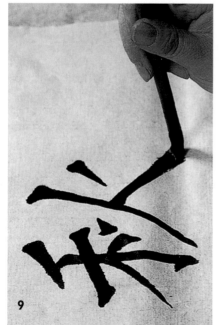

9

In China, calligraphy has always been highly esteemed. Fine examples are collected as enthusiastically as paintings. The structure of a character involves an interplay between its parts, and each character has a dynamic flow of energy underlying its direction that must not be interrupted.

Inscriptions and Seals

The inscriptions and seals on traditional Chinese painting are used to complete the meaning and composition.

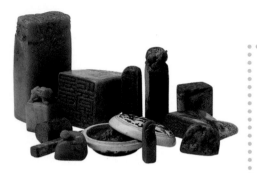

Any inscription must be appropriate; you might write that the painting was done in spring, or "when the leaves fall," for example. The calligraphy should support the meaning, the composition, and also the style of the picture. As a general rule, you should use *cao shu* on a freestyle painting, while a more careful work will need *kai shu*. Another rule of thumb is: the less color in a painting, the more calligraphy. You may lack the confidence to put inscriptions on your paintings at first, but seals are essential in free brush painting, to balance the composition. Seals are traditionally imprinted with red cinnabar paste, and must be used with discretion if the color is not to dominate. There are two styles: *yin*,

Practice impressing your seal on some spare rice paper before putting it on your painting. First check that your cinnabar paste is smooth and not oily. If it is oily, stir it with a spatula. Since the rice paper is very thin, place a wad of paper or other soft material under the place you want to imprint; the larger the seal, the thicker the wad should be. Make sure that the seal is the correct way up. Many a good painting has been ruined by applying the seal upsidedown. Press the seal straight down into the paste, so that it covers the entire surface. Then press firmly down onto the paper, supporting the seal with the other hand. Lift the seal up and away from the paper. Do not rock the seal while it is on the paper as it will smudge the imprint.

where the characters are incised into the stone; and *yang*, where the characters stand out in relief.

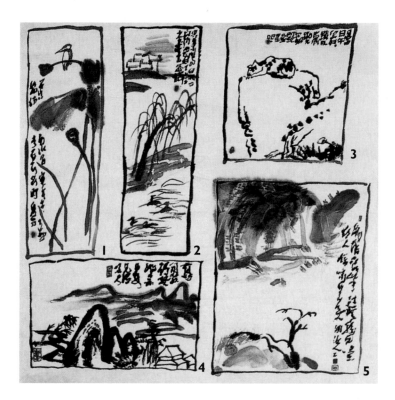

ABOVE *Examples of the use of inscriptions in composition:*

1 *The comparative fragility of the lotus stalks is supported by the strength of the calligraphy.*

2 *The inscription blocks off the corner, so that the movement does not escape. In this way, the energy is redirected into the painting and a connection is made between the separate parts.*

3 *The calligraphy breaks up the empty space and balances the mass of rocks.*

Plan where you will put the calligraphy and seals before you begin painting. Study the suggestions below, and as you progress through the book, notice how artists use calligraphy and seals to support the image.

4 *The inscription follows the movement of the mountains and occupies the white space that would be too long without it.*

5 *The two parts are linked by the calligraphy, which also forms a barrier through which the energy cannot escape.*

NAME SEALS

We suggest that you need a minimum of four seals for inclusion in your paintings: one free and three name seals (two medium and one small). The examples here will guide you.

Beware of the eye-catching color of seals, and remember that *yin* characters imprint with more red than *yang*. Use seals like spices—to add piquancy and interest.

YIN AND YANG SEALS

ABOVE *These large seals show the difference between* yin *and* yang *cutting. Their meanings are:*
LEFT *Ba Da Shan Ren (yin)*
RIGHT *House of Tang Hua (yang)*

RIGHT *These are free* xian zhang *seals. Their meanings are:*

1 *The view on this side is better*

2 *Art comes from study*

3 *Yellow Mountain pine tree*

4 *New ideas are better*

5 *Fascinating landscape*

LEISURE SEALS

1 **2**

3 **4**

5

BELOW *Where to place seals and calligraphy:*

1 *Greeting each other (name and leisure seals).*

2 *Value the empty space (two name seals, one free).*

3 *Signature away from seal to add interest.*

4 *Judicious placing to support the composition.*

5 *Seals greeting each other. (Do not put on same level.)*

6 *Greeting from top and bottom. (Do not put on same line: through the triangle formed by the man's shoulder.)*

7 *A subject such as bamboo needs more seals on one painting. The seals are like notes in music, with different emphases: large and small; loud and soft.*

8 *If there is only one seal, do not put it right at the bottom. Leave room for the composition to breathe.*

Seals fall into three basic categories. First are name seals, which can consist of a family name, given name, or *hao* (painting name). Usually done in formal script on square or regularly shaped stones. Second are seals bearing phrases or sayings (see far left). These are known as *xian zhang*. They are done in a free style on irregularly shaped stones, and are usually placed in one or more corners of the painting. Third are the seals of collectors, which are usually small.

The Importance of Ink

You might ask why the Chinese favor using black ink on white paper so much. The reason is that this combination provides the utmost contrast in the simplest possible way. It is thought unnecessary to crowd a page with colors when seeking to suggest the highest spiritual and harmonious ideals.

We have already seen the importance of good, strong brushstrokes in calligraphy, and these depend on the correct use of ink. The secret of using ink lies in knowing just how much water and ink to put on the brush. This will, of course, differ with the size of the brush and absorbency of the paper. It is something you can learn only with practice.

Ink in Chinese painting is therefore more than just black. It is complete in itself, and contains the property of suggesting every color, because it offers the possibility of so many amazing changes. It is not a negative black, but a concentration of all the colors and tones of the natural world. It is all the gradations between the palest gray and deepest black.

Ink is the essence of the beauty of traditional Chinese painting. With ink alone, you can show the perfect brushstroke, the energy of movement,

**INK PEONY by Zban Zi Xiang
(Early Qing dynasty)**
Look at how many effects the artist obtained using only the brush and ink. All stages are found on the flowerhead, from the transparent delicacy of the outer petals, through the controlled flow of dark into light ink on the inner petals, to the deep intensity of the stamens. The beauty of the painting is such that you do not miss the use of color.

and the emotion within you. There is nothing finer than the rich effect of Chinese ink on white paper. It must

be Chinese ink, because it is made in a special way; no other ink, or even black watercolor, will create the same effect, Learning to write with a brush enables the Chinese to absorb this feeling for the ink on rice paper from an early age. Practicing calligraphy, as explained earlier, will help you to do the same.

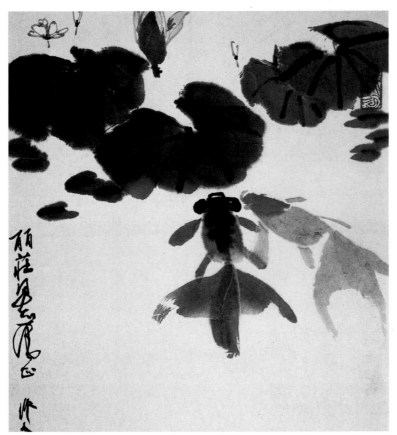

GOLDEN FISH
by Wu Zhe Ren
This picture shows the perfect use of varied brushstrokes allied to the complete control of ink flow. The flowerhead rises proudly from the density of the lotus leaves, like a beacon in the darkest part of the painting. The fish, in contrast, are almost translucent, and the different brushstrokes used to paint their fins give the impression of movement.

Another reason for choosing only black ink and white paper is that they symbolize purity. Try painting some strokes in pale ink and then gradually darken them—watching how the "colors of the ink" blend and bleed. As soon as you put the ink on the paper, most of the energy you are transferring to it becomes fixed there.

Generally speaking, building up from light to dark is more suitable for landscape painting, whereas in flower and bird painting, where you want to

TONES

If you are doing a large painting, the brushstrokes are usually strong, short, and very black. For small and fine paintings, a lighter shade is more usual. The key to both methods is the skillful manipulation of the ink.

focus on certain points, you begin with dark ink and introduce the lighter elements in relation to it. There are no hard and fast rules. It depends upon the subject. You should, however, try to differentiate your brushstrokes. Concentrate on creating balance and contrast between light and dark, wet and dry, hard and soft, and so on. Most important of all, before you start work, is to think about the picture you intend to paint. Think about the shades of ink you will use. To summarize, the essence of a Chinese painting lies in the contrast between the deepest black of the ink and the brilliant whiteness of the rice paper. The other strokes will range in tone between these two extremes. Do not be tempted to overdo the blackest parts or they will lose importance. Your aim should be to convey the feeling of immediacy and freshness.

MIXING INKS AND WATER

Ink in Chinese painting ranges through every tone from palest gray to deepest black, depending on how much water and ink you put on the brush.

If you do it well, the ink will retain the appearance of being wet even when it has dried. We call this impression "the spirit of the ink," or *qi* (see pages 212-213).

LOST IN THOUGHT
by Wang Jianan

The same brush and ink principles hold true in this modern painting. It relies on the subtlety of the ink tones to suggest a remote mountain region, where the scholar may contemplate the beauties of nature without interruption. The little color is subjugated to the inkwork and serves to reinforce it. Notice that the pavilion in the foreground is painted with the darkest tones.

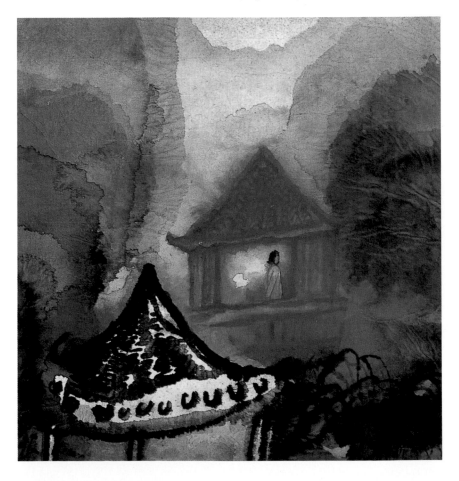

Starting Your Work

Before you start work, find a comfortable place to paint. You may be lucky enough to have the space to permanently leave your equipment out ready to use. You may have to clear away to prepare your table for meals, or pack the equipment into a bag to take with you to classes.

Once you find a quiet and comfortable place, you can begin to set up a "Scholar's Desk" for yourself. This is how the Chinese artists began their painting. A piece of blanket or felt, preferably white, should be placed on the table, to provide a cushion on which to paint. The paper is so thin that it would stick to the table if it did not have a blanket underneath it.

If you are right-handed, place the following items on the right of the blanket. If you are left-handed, they should be placed on the left. A water pot, a white plate, tile, or palette,

brushes, inkstone, ink stick, and a piece of paper towel should all be arranged beside the blanket and within easy reach.

Sitting at the scholar's desk should be relaxing and comfortable. Place the feet flat on the floor, hip width apart, and sit with a straight back, a straight head, and a straight heart. This last thought refers to the way you will be thinking about the picture that you are about to paint. Will it be a pleasing composition; will the brush strokes be varied and properly executed; and will the picture be one that is true to yourself?

To get yourself in the right frame of mind, first grind your ink. Place a little water in the inkstone and rotate the ink stick in the water, holding it vertically and grinding until you get a lovely, fragrant pool of sooty black ink.

Now load your brush by dipping it into the water first. If you are using a large brush, watch for the little bubbles

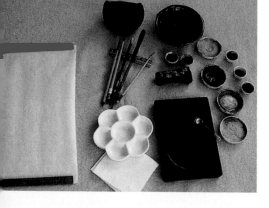

LEFT Assemble your equipment and lay it out on the table to start. You should ensure that you have good lighting conditions, room to paint freely, and a seat of adequate height.

to stop drifting up from the ferrule before you take it out of the water. This ensures that the whole ferrule is soaked in water and that the brush isn't dry in the center. Now wipe the brush tip on the edge of the water pot to remove excess water. Dip the brush into the ink and, when it has soaked up enough ink, wipe out the excess on the rim of the inkstone.

Place a piece of paper on the blanket and hold the brush as described in the earlier section on brushes (see pages 10-12). It is easier to paint in the Chinese style if you keep the brush perpendicular to the paper. Make sure your elbow is raised at right angles to the body and that your palm is "hollow."

Press just the tip of the brush onto the paper surface and draw a horizontal line. Draw another one under that one, remembering to breathe out as you paint and to breathe in as you lift the brush off the paper. Once you have done a few lines, using just the tip of the brush, try pressing the tip onto the paper a little harder. Check that the index and middle finger are still holding

LEFT When you are ready to start, add water to the inkstone with a salt spoon, dropper or brush.

CENTER When grinding the ink, protect your painting and steady the stone with your other hand. Try to grind with a steady, fluid motion.

RIGHT When the ink is of the desired consistency, wipe the brush on the inkstone or palette to release some of the ink/color and to adjust the amount of liquid within the brush.

the brush against the thumb, and that the brush is perfectly perpendicular, and execute several thicker lines. Finally, press the brush right down to its heel on the paper, painting the thickest line that you can with the brush held perpendicular. (Holding the brush horizontally to the paper as you painted would give you a thicker line than this.) All these initial lines are painted with the same pressure on the brush from the beginning of the line to the end.

The next marks to experiment with are those in which the pressure is

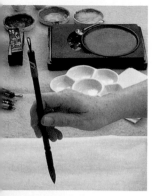

LEFT *Any powerful stroke or one that needs strength requires the brush to be held in an upright position. An upright brush and additional pressure at the start is required for stems, etc.*

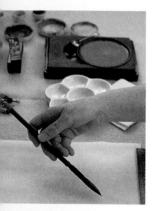

CENTER *For soft petal shapes, however, you will need to use an oblique brush angle. This will be required in both vertical and horizontal directions. The wrist and grip on the brush, therefore, must be used flexibly enough to allow circular movement.*

BOTTOM *In order for the hand/wrist to be able to move the brush in all directions, the arm must be held away from the table and be free from support.*

varied as you paint the line. Start on the left side of the paper and begin to paint using just the tip of the brush. Gradually increase the pressure on the tip as you paint, then lift the brush back onto its tip for the last inch (2.5 cm) or so of the line. The line should look thin at either end, or thick in the middle. Do several of these lines, keeping an eye on how the brush is held, on breathing rhythm, on the shoulder-high elbow, and on that hollow palm.

Finally, as part of this preliminary exercise, try to paint a line with several variations on the pressure as it is painted. To make it easier say "Press" and "Lift" and "Press" and "Lift" as you paint the line. The opposite can be tried. Begin by pressing your brush into the paper at the beginning of the stroke, then "lift" and move across the page onto the tip of your brush, ending with another press at the end of the stroke.

If you can get hold of some newspaper, plain or printed, then it is well worth practicing these strokes on that. Just familiarizing yourself with the hold, the vertical painting position, and the loading of the brush, takes time. Other strokes to practice may include: dots and dashes; lifts and presses of both short and long lengths, and flicks; blobs; and short or long lines with the brush held horizontally to the paper.

When painting soft strokes such as petals or leaves, the brush should be slanting; for stems or branches it should

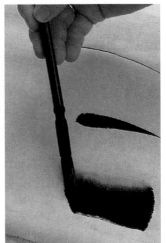

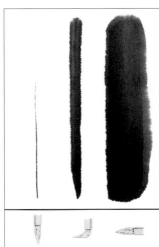

FAR LEFT *How the brush is held is of great importance to the success of the painting. With the brush held like a chopstick, use a light pressure with an upright brush to achieve a fine line.*

LEFT *Pushing the brush while applying increasing pressure will give a thin start to the stroke, followed by a line that gradually thickens. How quickly this happens will depend on the amount of pressure applied.*

FAR LEFT *Use the side of the brush to achieve a wide stroke. All of the brush may be used, but it is best to leave some "in reserve."*

LEFT *Different marks can be made on the painting depending on the pressure, loading, and part of the brush that is in contact with the paper. The three symbols denote, from left to right, an upright brush, an upright brush applied with pressure, and an oblique brush.*

be held upright. Try to think of the strokes as soft or powerful and adjust the angle accordingly. For a soft stroke the tip of the brush will be to one side of the stroke; for a powerful or strong stroke the tip will be the main part of the brush in contact with the paper. The more pressure you apply to the brush, the broader the stroke.

43

BELOW *Strokes are shown varying in thickness and with differing start and finish techniques. The brush is lifted and lowered to give the desired effect.*

Using the palette and some water, dilute the ink to get as many shades of gray as possible. Chinese ink is considered capable of dilution into seven separate shades, black plus six different grays. Practice putting these shades onto the paper. Try to control the amount of liquid in the brush to prevent the strokes from running.

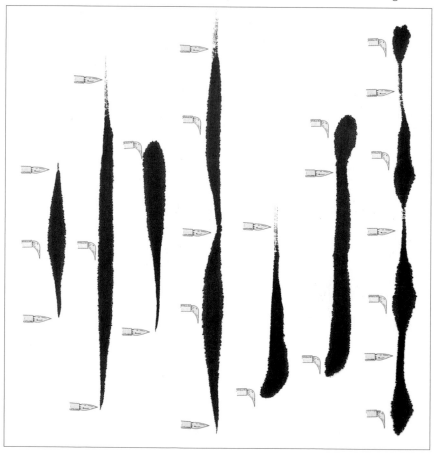

Because lines are painted in different ways, you should know the effect you wish to create before putting brush to paper. For a fine line, wipe the brush well on the palette, hold the brush upright, touch the paper very lightly, and move quickly. For a thick, wet line, you can still hold the brush upright, but allow more liquid in the brush and move more slowly. More liquid will flow from the brush onto the paper and give a thicker line; the outline will also be less distinct and sharp. Experiment by placing various parts of the brush onto the paper; the point will give one effect; the side of the brush another. Similarly,

pushing it will be different from pulling it and simply leaving the brush on the paper for a few seconds while more ink is absorbed will give yet another effect.

BELOW *By varying the way that the brush is pulled across the paper, several shapes can be made. Where long brushstrokes are required, variations in loading and pressure will create stunning effects. If more than one color is used in the brush, these colors will gradually blend as more strokes are carried out with the one brush loading.*

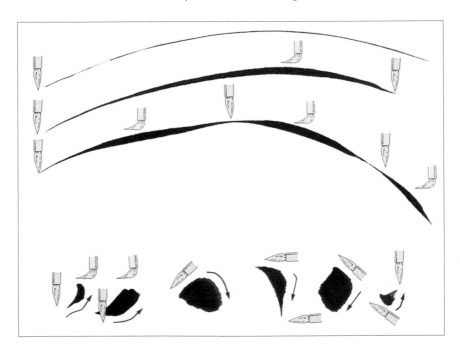

A SIMPLE PAINTING

Having practiced various strokes, start putting them together to form flowers, rocks, or animals. Start with something simple, copy the samples of flowers and leaves and try to put together a series of strokes into a recognizable shape. Remember that flowers turn in different directions and also face toward the sun. They will be at various stages of growth, and may even have petals missing.

LOADING THE BRUSH WITH COLOR

Much the same as loading the brush with ink, loading the brush with color involves wetting the brush first. Squeeze three blobs of color onto your plate/palette or tile. Red, yellow, and blue are the most versatile colors. Dip your wet brush into one of these colors, filling it three-quarters full. The heel of the brush is always left empty. Now, holding the brush vertically, try laying down all the ferrule. This will give you a "teardrop" mark. Now load the brush with the palest color. (This might be yellow, for instance.) Once the brush is three-quarters full, dip the tip of the brush into another, contrasting

color. Now, when you paint the "teardrop" shape, you will see the two colors in the mark.

To paint a bamboo cane such as the one illustrated on the opposite page, you will need to load your brush with yellow or green. If possible, slightly flatten the brush on the rim of your plater or palette. Now carefully dip each side of the brush into a dark color such as ink or blue. Paint in a broad, firm stroke and you will see a bamboo cane appear magically.

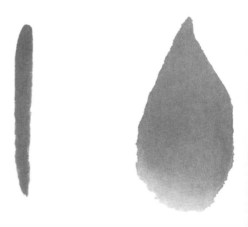

RIGHT *Single-brush loading—one color in the brush. If the brush has previously been placed in water, and the color is not blended fully into the brush, then a pale base will result. This effect can of course be used deliberately.*

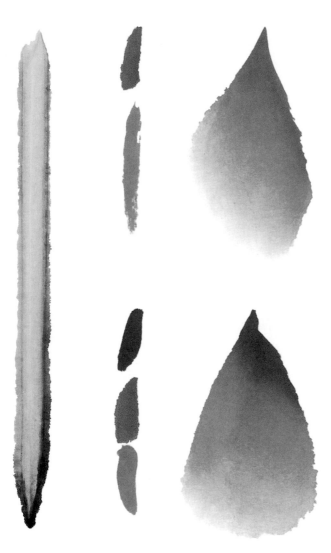

FAR LEFT *Tube loading—the brush can be loaded with the main color and then dipped on two sides into a darker color. This will create a tubelike effect that will be useful to describe cylindrical shapes such as a bamboo cane. This method of loading will need practice.*

TOP LEFT *Double-brush loading—first load the brush with the main color, wipe the tip of the brush against the palette, and then load the tip with the second color. This will give a graded color stroke if shades of the same color have been used as in this picture.*

BOTTOM LEFT *Triple-brush loading—load the brush with three colors in equal thirds of the brush. Judicious use of this technique with different shades rather than contrasting colors can add interest and form to your painting.*

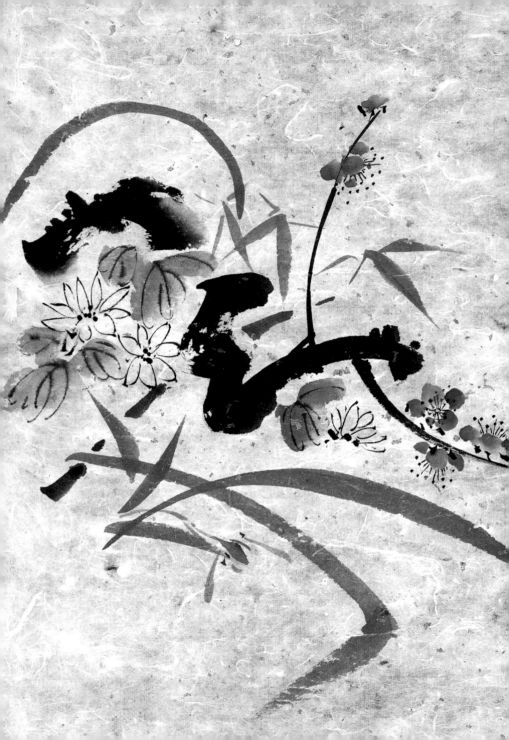

The Four Gentlemen

In order to provide students with a catalog
of useful strokes, the Ming Dynasty scholar
Chen Jiru devised a superb teaching
plan called "The Four Gentlemen."
Combining the plum, the bamboo, the
chrysanthemum, and the orchid, these four
subjects are designed to give students a
wide variety of strokes to practice. Once a
student has mastered these strokes, they
will be equipped with the necessary skills
to progress with their painting.

This painting by Jane Dwight combines all
the flowers of the Four Gentlemen

Orchid

Representing spring, the orchid is feminine and fragrant. In China it is said that "you need half a lifetime to learn how to paint bamboo but a whole lifetime for the orchid." But don't let this put you off—the project that follows is broken down into easy-to-follow steps.

The orchid was originally a secretive plant found only in remote locations, behind rocks or by the shores of lakes. In China today it has been cultivated into more than 100 varieties. The famous poet Qu Yuan (c.343–278 B.C.E.) wrote a poem about the orchid in which he describes the delicacy and refinement of its flowers with the green leaves wafting in the breeze: "Oh, how pure is the autumn orchid blooming in a hall full of beauties."

The first painter of orchids is considered by many to have been Mi Fei in the Northern Song dynasty. Since that time artists have interpreted it in innumerable different ways. It is one of the most useful plants for imparting the skills of Chinese painting. Where bamboo has leaves but no flower, and plum blossom has flowers but no leaves, the orchid has both—and the painter must strive to capture their essential qualities, which require different techniques. The leaf of the orchid is one of the most difficult strokes to paint well. You need excellent coordination of hand and arm, with the movement flowing from the shoulder in one smooth sweep.

ORCHID by Han Qiu Yen
This traditional painting has an asymmetrical composition. The calligraphy occupies a central position stabilizing the composition. The function of the falling flowerheads is to allow the movement to drift gracefully beyond the picture edge.

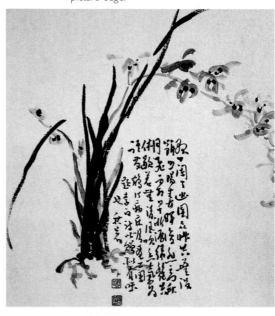

Main Leaf

Think of this as an elaborate *cao shu* stroke using the entire arm. One brushstroke requires almost 270° of movement, changing direction to express the sinuous turning of the leaf. The pressure on the paper must be positive, yet reflect the thinness and suppleness of the leaf.

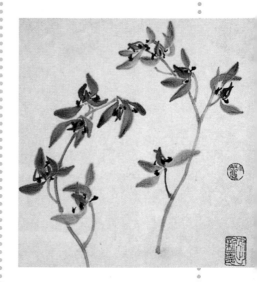

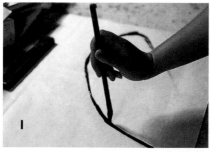

I

I *Begin by holding the orchid and bamboo brush in the* zhong feng *(center brush) position. As you start the stroke, hide the tip.*

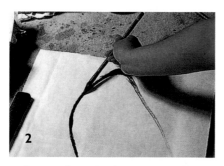

2

2 *Continue the stroke, changing to a* cefeng *(side brush). Still with a side brush, describe a quarter circle, as though from 1 to 3 o'clock.*

You should make sure you get to know your subject by drawing it. The concentration on line will help you to make the correct strokes when you use the paintbrush. When you are ready to paint, practice the stroke for the main leaf first (see left). After practising this important leaf you can set up the others in relation to it.

Last come the flowerheads. Above are some examples of flowerheads for you to copy. Notice how many different aspects there are. Do not make the stems too stiff. Where the stamens can be seen, they should indicate the direction of the flowerhead faces.

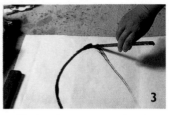 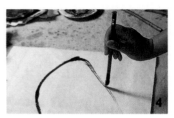

3 *The hand turns over, so that the palm is facing down. This is the start of the* tuobi *(dragging stroke). As you make this movement, the fingers are also rolling the brush, first counterclockwise, then clockwise.*

4 *The* tuobi *finishes, and the hand returns to its starting position.*

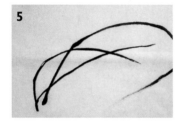

5 *The first few strokes are crucial to the whole composition. After the long turning stroke that you have practiced, paint two or three crossing it. These secondary strokes should complement and endorse the movement of the first stroke but not dominate it.*

6 *Now add the tertiary group of leaves. Some should turn away from the main group; some should intersect with them; all should be subordinate to the first group. The aim is to achieve interesting relationships between the leaves. Take care not to make them all spring from the same base.*

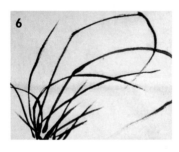

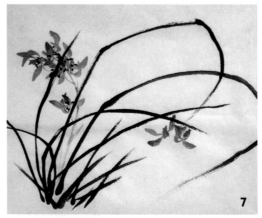

7 *The flowerheads are composed of dots. Using the white cloud brush, they are assembled in groups of five to suggest the flower. They should peep in and out of the leaves, which appear to cradle them in an embrace.*

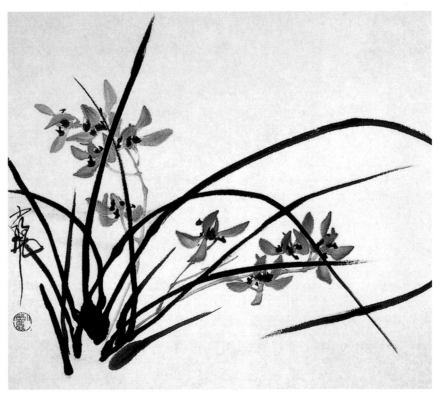

8 *The finished painting. There are three areas to bear in mind: technique, mood, and composition. The picture is composed of line and dot, gou, and dian. Every line is done in a special order, just like the calligraphy strokes. The mood can change according to the time of day or location, but always try to capture the orchid's refinement. The subject lends itself to asymmetrical compositions. Here, the first large stroke goes out of the picture and returns, giving a feeling of extension beyond the frame.*

Bamboo

This signed picture is by the artist Qu Lei Lei, who paints and exhibits in England. Bamboo represents summer, honesty, and strength. It is wonderful to paint. Try standing to do it.

Prepare your ink and dilute some of it in a separate dish. Dip your brush into this gray ink and wipe off the excess. Follow the instructions for illustrations I and 2 to complete the canes of the bamboo. Now paint the side shoots.

The side shoots supporting the leaves join the main stem on alternate sides. Use the tip of the brush by holding it vertically. Paint short lines as shown in Qu Lei Lei's picture.

By careful brush loading, the cylindrical stem can be suggested, either by loading the tip of the brush with darker ink when using the brush sideways, or by adding the same to the sides of the brush if using a pushing stroke.

The condition of the plant will depend on the weather and the growing season. Is the bamboo in flower? Is it raining or snowing? Has the bamboo recently been buffeted by winds— enough to tear the ends of the leaves, or

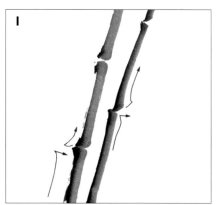

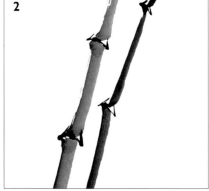

I *Using an upright brush and starting from the bottom of the paper, push the brush upward, moving to the left as a node is reached. When the brush is applied to the paper again, move it to the right and then upward.*

2 *Add the node markings in "burnt ink" so that emphasis is given to the joints and they are made to appear stronger. There must be a marked contrast between the stem color and that of the markings.*

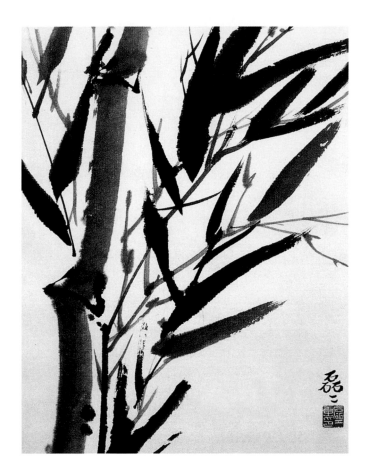

is it in windy conditions and all flowing one way? Think about all these variations before and during your painting.

Make sure there is sufficient shading in the ink tones, and that the leaves have substance. If the plant is young, the leaves will point upward and be quite stiff. As the plant ages they turn downward but never look limp.

In the past, well-known *literati*

painters spent their whole lives just painting bamboo, often in a single color. Some were famous for using red, green, or purple to paint this plant although, the most traditional way to paint bamboo is in shades of black ink.

Western artists find it difficult to leave sufficient space in their work, especially with this subject. There is a temptation to keep adding more

leaves. Look carefully at completed paintings and try to emulate the spaces and the general "feel" of the plant. To achieve a good painting of bamboo is very satisfying.

RIGHT *These examples of leaf groups have such names as "landing goose" and "flying swallow," which accurately describe their shape. It is essential that the leaves are painted in a lively way and are not made to look like bunches of bananas!*

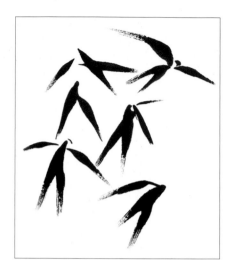

LEFT *This is a different way of painting bamboo, using an XL sheep-hair brush for the cane.*

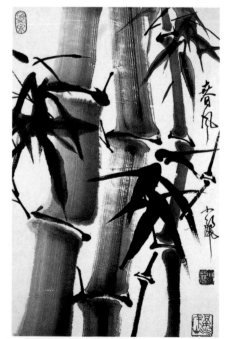

RIGHT: SPRING BAMBOO by Cai Xiaoli.
Here is an example of advanced bamboo painting on silk or meticulous paper. All the canes and leaves have been outlined first. Beautiful copper crystal pigments have been used, in many layers, to create this effect.

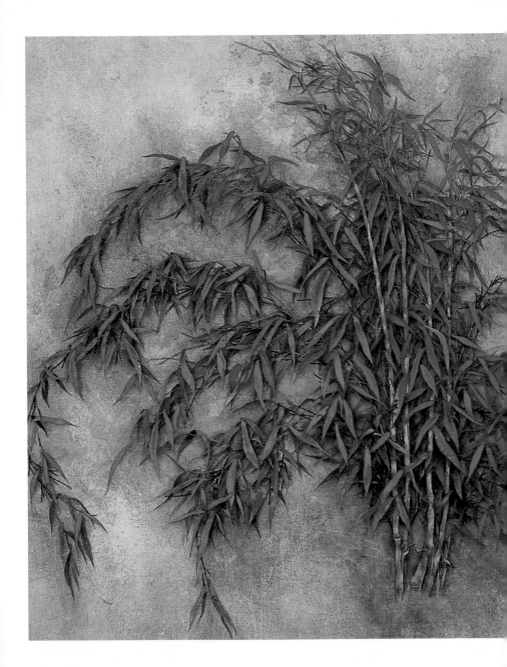

Chrysanthemum

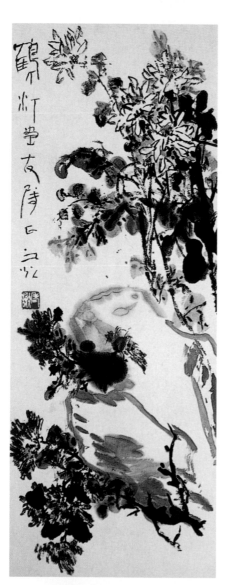

The chrysanthemum has always been popular in China because it continues to flower in the fall long after all the blossoms of summer have faded. Furthermore, it does not end the season on a subdued note but displays its glory in a riot of color; as though defiantly facing up to the harsh winter ahead. It therefore represents the fall and cheerfulness in the face of adversity.

For these reasons, the scholar-painters, in particular, identified with this flower. They had a strong sense of responsibility for society, yet felt themselves to be under pressure from the ruling classes. In modern times also, many Chinese like to bring this plant into their homes to remind themselves that it is possible to triumph in adversity, and to brighten their surroundings. A popular entertainment is to sit and drink wine while contemplating the virtues of chrysanthemums.

AUTUMN by Xie Zhe Guang
This example captures the essential characteristics of the flower especially its vigor and wonderful display of color.

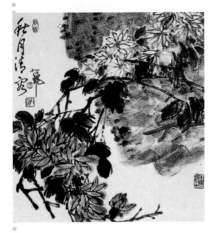

The brushstrokes used in painting this flower should be strong and free to reflect its character. The contrast between the dark leaves and the brilliant flowers needs to be brought out. Practice in particular loading the brush with both wet and dry ink. For example; use a wet lower brush loaded with dark ink, and a drier tip loaded with light ink, on the same stroke. Start with the flower nearest you. Make the flowers behind it smaller, and turning in a different direction. A common mistake is to make the petals too sparse. They are actually quite closely packed, and the whole flower gives the feeling of being an almost solid ball.

The completed painting (left) shows how the elements of the step-by-step are combined. Notice the placing of the plant in relation to the edges of the paper, how the spaces are set up, and the contrasts in tone and color. Note also how the imagination used the images from nature to portray the essential characteristics of the chrysanthemum rather than a photographic representation. Compare it with the painting **Autumn by Xie Zhe Guang** (opposite.)

See Step **2** on page 60. This is the order for loading your brush with the colors you should have preprepared.

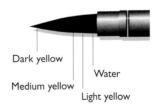

Dark yellow

Water

Medium yellow

Light yellow

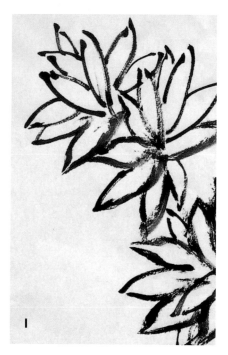

I Before starting Step **I**, mix the color for Step **2**. Using ink on an orchid and bamboo brush, draw the shapes of the petals with calligraphic brushstrokes. Vary the strokes by sometimes using the tip of the brush, sometimes the side; by alternating between light and dark ink; and by using a wetter or drier brush. The speed of the stroke will also add variety: slower for a dry brush; quicker for a wet brush. Build up each flower gradually, remembering to show profile petals as well as full shapes. All petals should come to the center of the flower.

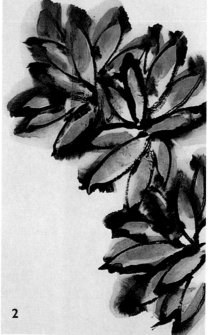

2 Fully load a medium sheep-hair or white cloud brush with light yellow paint. Add a medium yellow to the center part, then dip the tip in a small amount of dark yellow. Fill in the petal shapes but not too precisely. Vary between touching the ink line and going over it. Do this while the ink is still wet to gain the effect of shadow as the colors merge. At the top edges of the petals, you can leave a white gap between the line and the color. A little glue can be added to the color to make it more intense.

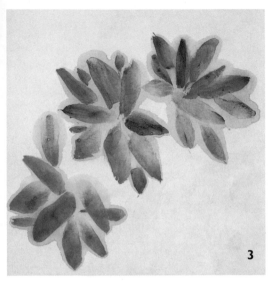

CHRYSANTHEMUM FLOWERHEADS

3 *Another method, known as* mogu *(without bone) is to begin with color, using a white cloud brush and painting the petal shapes in a free brush style. Vary the intensity of color, making the entire flower darker toward the bottom. Leave space between the petals in this version, or your ink strokes will be too close together.*

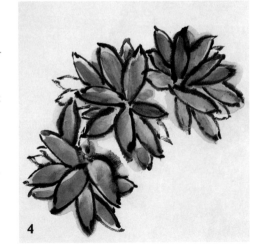

4 *While the pigment is still wet, draw in the outlines, taking care not to follow the contour of the color too closely. Again, you can be inside or outside the color, and can leave an area of white between the line and the color. To create the leaves for both painting methods (see picture on this page), load a medium sheep-hair brush with light ink, with a little indigo on the tip. Use different brushstrokes to show both full-face and side-view leaves, varying their tone and size. Before the color is dry, draw in a few veins with an orchid and bamboo brush. Use pure black sparingly so as to ensure its impact. Next draw the stalks, utilizing bold brushstrokes, and paint with a mixture of ink and a little brown. Join the leaves to the stalks with a fine brush and dark ink. The large stalks resemble* cao shu *calligraphy and the smaller* kai shu.

61

Plum Blossom

Like bamboo, plum blossom occupies a very special place in the Chinese heart. It represents winter and hope because the blossoms appear when temperatures are still bitterly cold.

The Chinese plum is a plant of the wilds, growing on remote hillsides where it might live for over a hundred years; the same plant was brought from its natural habitat to be cultivated in the gardens of connoisseurs, where it was nurtured to produce magnificent blooms that come before the leaves, defying the winter elements.

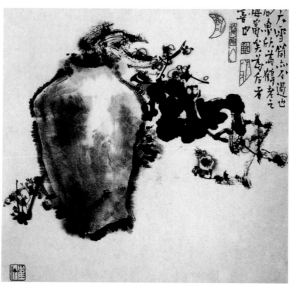

EARLY SPRING by Cai He Ding
In this painting notice the contrast between the positive delineation of the branches and the varied movements of the flowers.

The contortions of the wild plum reminded onlookers of a ferocious dragon. When transplanted to gardens, it was judiciously trained to give a similar aspect. The old branches were pruned to represent the body, and the new growth was given space to develop straight and true, like an iron rod. Another admired characteristic is the constancy of the plum, returning each year to be the first flower to display its attractions, like a peacock parading before its mate. It therefore also symbolizes undying love.

Begin your studies by researching the characteristics of the plant. Make drawings so that you are familiar with all

TIPS
·····

- Do not attempt to make your painting exactly like the plant. You are aiming to capture its spirit.

- Keep the whole composition in mind while working. The brush needs to move quickly to convey the ruggedness of the old trunk, but space must be left for the positive direction of the new branches and the delicacy of the blossoms.

- Think about the space left between groups of blossoms and branches.

- The first few strokes are the most important, because they establish the spirit, or qi, of the whole painting.

fully opened "adult" flowers are in conversation with the younger ones, darting in and out among them. In this exercise, the blossoms are painted in the freestyle (or Xieyi) method (see pages 72-73). You could also try painting blossoms in outline as shown on pages 74-75.

I *Begin by using an orchid and bamboo brush loaded with light ink. Add dark ink to the tip. Lay in the main structure of the painting, pausing where the brush turns, then continue in a different direction using both center and side brush. Remember to leave enough space for the blossoms, which are added later.*

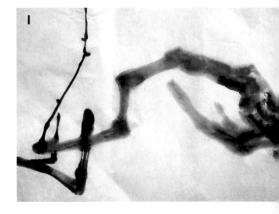

stages of its development. Remember that not all the blossoms face the same way, nor are they all the same size. Some blossoms are full-blown; some are still in bud. Those toward the bottom of the plant tend to open first. Contrast the blossom grouping: some should be clustered together; some should stand alone. They should also be in a reciprocal relationship, as though the

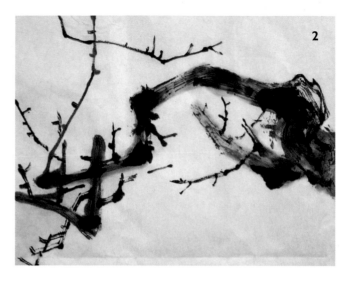

2 *While the first ink is still wet, take a second wolf-hair brush, such as jade bamboo, load it, and then squeeze it with your fingers to get rid of the excess water and to spread out the tip. Paint the details of the trunk, using a center brush. If you want to leave "flashing white," you must move fast. Add the new branches, making them straight and strong.*

3 *Start painting very simple blossoms. Use a sheep-hair brush, such as white cloud, and try to reproduce the essential shape and direction in one stroke. The basic color is a light pink, but vary the tones of individual petals by adding a little indigo to some brushstrokes, and a little red to others. Do not mix them too much on the plate; allow the colors to blend on the paper.*

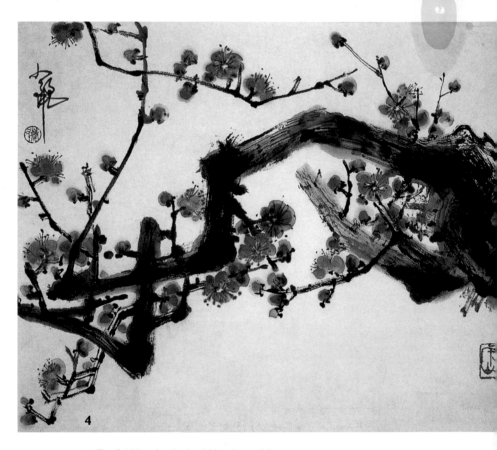

4

4 *The finishing details should be done while the paint is still wet. Using a small, dry wolf-hair brush, add the stamens with light, rapid strokes. These can also help to indicate the direction of the blossoms. Now is also the time to reconsider your composition: You can add dots to the trunk and branches to strengthen them at salient points*

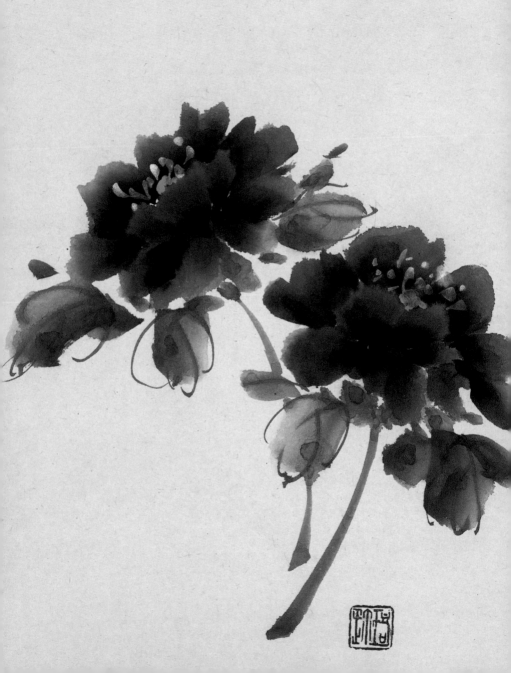

Flowers

"All the flowers in the world rival one another in their beauty and give pleasure to the hearts and eyes of men. They offer great variety. Generally speaking, the wood-stemmed plants may be described as having a noble elegance, the grasses a soft grace."
From "The Tao of Painting" by Mai-mai Sze

This painting by Jane Dwight shows a peony with noble elegance

Subject Matter

To reproduce the images of traditional Chinese painting, you need to know something of the ideas that lie behind them. A subject is always chosen for a reason, and the subject matter of Chinese art runs like a thread through all creative endeavors and into everyday life.

Traditional Chinese painting falls into two broad categories. The first comprises serious work for which the artist makes comprehensive preliminary drawings before composing a highly finished painting; it will probably have washes and details added after the main elements. The second category, which is known as *xiao pin* painting, is an important part of what you will learn in this book. *Xiao pin* literally means a "simple artistic creation." When applied to painting, it conjures up an image of the artist engaged in lighthearted ink play as the brush ceaselessly cavorts back and forth on the paper. That does not mean that it is a trivial exercise. Many of the greatest artists painted entirely in this manner, and *xiao pin* paintings are displayed in galleries just as much as "serious" paintings. It does mean that you need to perfect the skills of handling the brush and ink before you begin, so that you can complete the painting with dexterity.

SUMMER LOTUS by Cai Xiaoli
This painting shows the lotus in one season, but it is equally popular in its fall, winter, and spring aspects. The lotus is admired for its purity and because it raises its beautiful flowerhead far above the murky waters in which it grows. It thus shows humble people how it is possible to succeed even when their beginnings are less than auspicious.

One of the main subject areas of traditional art is flower painting. Often, birds and animals are included in representations of flowers. This is because every traditional subject has an inner meaning or symbolic connotation, and birds and animals are often associated with particular plants to reinforce that idea.

This approach to painting was primarily developed by a small group of highly educated men who dominated artistic standards until the end of the 19th century. They were known as the "literati," but were renowned for their prowess in all of the arts. For the purposes of this book, we refer to them as the scholar-painters. The subjects they chose to paint are the foundation of traditional Chinese painting.

The most famous plants associated with the scholar-painters are the so-called "Four Gentlemen" (see pages 48-65) Bamboo, Orchid, Chrysanthemum, and Plum Blossom. The title was given to the four plants because the scholar-painters found certain characteristics in their growth that they could identify with and respect.

The illustrations on this page and the previous page are in "gongbi" style; in other words, they were painted on nonabsorent silk or meticulous paper.

ORCHID LEAVES by Cai Xiaoli
This highly wrought painting is a masterpiece of understatement. The orchid stands for perfection in womanhood, symbolizing humility and refinement. Here it is so self-effacing that only the leaves appear, but they are painted with such an interweaving and vitality against the silver background that you can hardly believe this is just a picture of leaves. The utter simplicity seems to make a statement of profound truth.

Ink and Color

In flower painting we do not attempt to reproduce the colors of nature exactly, but to express our emotional response to what we see. This response will be personal and different for each artist.

As mentioned earlier, the tones of black ink are already seen as color. Any additional color is therefore regarded as an adjunct to ink and not an improvement on it. This is why the range of colors used in Chinese painting is relatively limited. One way of showing a personal response, in *xieyi* (free brush) painting, is by the use of contrasting colors in a host and guest relationship. When contemplating a flower subject, the mind's eye is impressed by one dominating color that sets the mood. This major color is probably the flower. The stems and leaves are not painted with greens, but in tones of black ink so that the flower appears brighter and fresher by contrast. Another way of painting the stems and leaves uses a little indigo mixed with ink. In this case they are in a subordinate role to the flower; and the whole painting is dedicated to one color mood.

WARM AND COLD COLORS AND INK

Ink has the almost magical property of generating warmth or cold, which is taken up by and from colors associated with it. The artist can use this to convey personal feelings about a subject. The hot colors are the reds, yellows, and browns; blues and greens are cold. Ink is a kind of "middle" color; when juxtaposed to a cold color, it gives the impression of warmth, and vice versa.

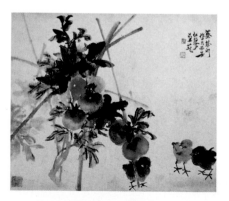

COUNTRY PLEASURES by Cai He Zhou (1910-71)
This traditional painting illustrates the use of contrasting, host and guest colors. The leaf is painted with ink so that the color of the tomato appears even more vivid. The painting utilizes color to suggest a rustic style of living.

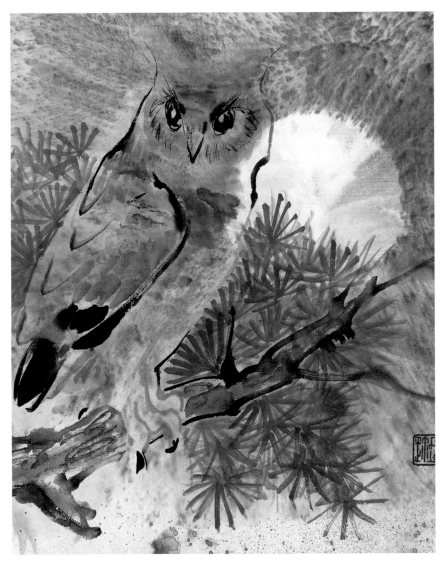

THE OWL IN THE MOONLIGHT
by Jane Dwight
*This creation is dominated by cool indigo
and ink.*

Painting a Peony in the Freestyle (Xieyi) Method

When painting flowers, there are two main methods that can be used—the freestyle method and the outline method. These two styles are demonstrated on the following pages by examining how to paint a peony. It is an ideal plant to begin with. It has lots of petals and is therefore forgiving to the artist.

I *Begin by loading a large brush with pink. Dip the tip of the brush into ink and move the tip a little on the palette to allow the ink and pink to mix slightly. Now hold the brush horizontally with the tip pointing toward you and put the whole ferrule down on the paper. "Dance" the heel of the brush across the paper for about half an inch (13 mm) and lift off. You will have painted a perfect petal.*

I

2

2 *Do another one exactly the same way right next to the first one. Now do another one on the other side of that first petal. Once you have done three petals in a row, you may need to reload your brush.*

3 *The next three petals should be painted directly above the first three. Now you can fill in the shape of the bloom with further "dancing" strokes, reloading your brush when you need to.*

3

4

5

4 *To paint the leaves, load the same brush with pale green and dip it generously into a darker green. Tip the brush in pink and paint the leaf with the side of the brush.*

5 *You will need to paint the veins of the leaf with a finer brush, and in a darker color, while they are still slightly damp. Try indigo or the ink and pink mix or dark green.*

6 *Finally, add stems in a green or brown color and dot the centers of the flowers with mineral green. The stamens can be painted with a thicker mixture of white and yellow.*

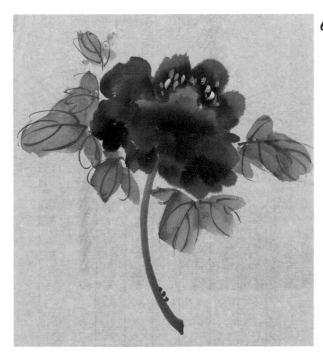

6

Painting a Peony in the Outline (Xian Miao) Method

Here is another peony, but this time created using the outline method. As you will see, the effect achieved is quite different from that of the freestyle method, giving a more precise and finely detailed picture.

I *The line used to depict the flowers is fine and light. It is a calligraphic stroke done in pale, diluted ink. The brush must be held vertically this time and it would be valuable to practice the stroke on rough paper first. Press the tip of the brush on the paper and then do a fairly quick semicircle, followed immediately by another one. This describes one side of the petal. Put the brush tip down close to where you began and do two semicircles, in the opposite direction, to complete the petal.*

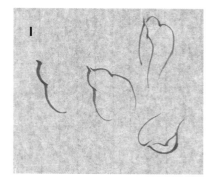

2 *By varrying the relative sizes of the petals (and semicircles) the bloom will appear less mechanical and more natural.*

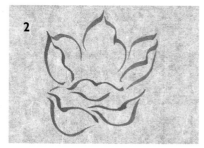

3 *Continue adding petals until you have a nice blowsy flower. If you varied the size of the petals as suggested in step 2, you should be left with a lifelike image.*

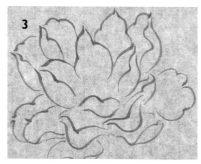

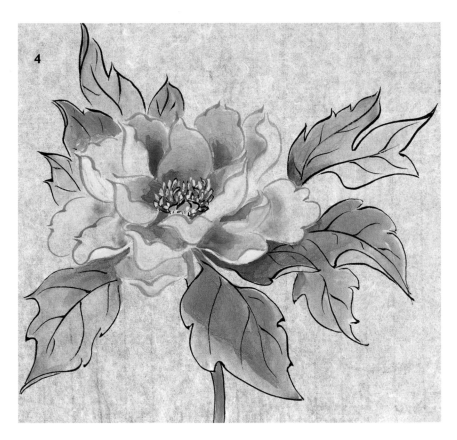

4 Once you have completed the bloom, the painting can be finished off with freestyle leaves (see page 73). Outlined leaves are done in darker ink and then color is added while they are slightly damp. The stamens and centers of the flower are done in exactly the same way as those shown in the freestyle demonstration on pages 72-73.

Wisteria

Wisteria is a popular plant in China and serves here as an example of climbing vines. For the Chinese it represents the stages of life in a poetic way.

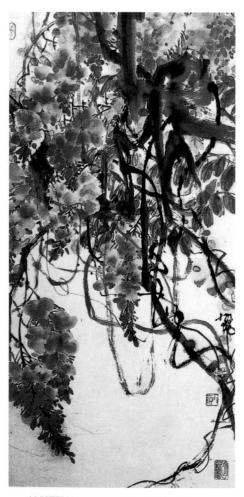

WISTERIA WATERFALL by Cai Xiaoli
This painting captures the grace of the flower.

Try to picture the characteristics of the wisteria before you start to paint. When the flowers first appear, they reach upward toward the sky. As the florets open, the clusters become heavier and fall, like a waterfall tumbling down a ravine. The vine itself is remarkably strong. In former times, people used it to make ropes for climbing and lines for fishing. When you are painting the vine, you must feel this strength with your brushstroke. In contrast, the old branches have endured endless hot summers, which have dried them up, revealing the scars and rigors of a long and arduous life. Different brushstrokes are needed to show these disparities.

Practice painting the vine first. This is the element that will give the painting its vitality and spirit. Do not worry if the paint line is not continuous. If you perform it with confidence, the energy will flow between the breaks and give it vitality.

In this lesson we continue to study the turning stroke *zhuan bi*. We will start the actual picture with the flower clusters, which are going to be our focus. If you plan to do a large painting, you should begin with the branches and leave space for the flowers.

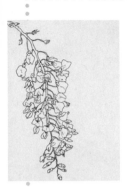

You should begin by copying other Chinese paintings of the subject, which will give you the necessary feeling for the difference between Western and Chinese paintings. Only when you are familiar with how other Chinese paintings deal with a particular subject should you go into the field to study your subject at first hand. Make detailed drawings, as shown above, and you will be equipped to do even better work in the studio.

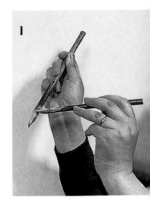

I Begin by practicing loading the brush. Wet your brush, then load it in four stages; the quarter nearest the shaft is pure water; the next quarter is green, mixed with a little red to a medium tone; the next quarter is a little darker than the green and red medium tone; the tip is touched lightly into indigo and both reds. Finally, use one brush to add white to the base of the other brush (see above). This is done so that you do not overload with white. Do not mix the colors too much on the plate. As the brush executes the strokes, the colors will mix naturally, giving you a variety of different tones.

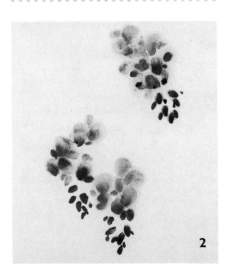

2 Now you are ready to begin painting. Start from the bottom of the flower cluster, using a white cloud brush. At the top of the cluster, the petals are almost pure water. Do not be tempted to reload the brush too often. As you paint more petals, the color on the brush becomes lighter, and this adds to the effect. Remember to not make your flower groupings too regular. If there are three clusters, put two together and one slightly apart.

3 Add the leaf shapes with a sheep-hair brush. Show both old and new growth, differentiated by color loadings. The old leaves are done with a blend of ink, indigo, and yellow; the young ones with ink, indigo, and a little red. This contrast is important, not only pictorially but also for its wider connotations of balance and reflection of life's pattern. Remember to group the leaves naturally. While they are still wet, add the veins with a fine wolf-hair brush.

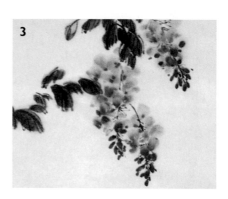

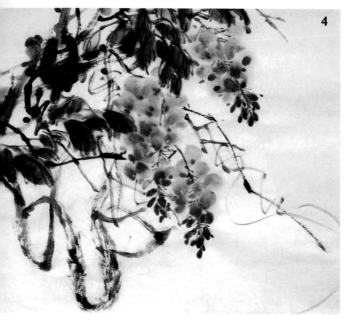

4 The main branches are the framework upon which all else depends. Using a mountain cat brush paint them with slow, controlled brushwork, using light ink mixed with earth brown, sparsely loaded to give the effect of age. For the vine, with its more vigorous growth, use dark ink and more flowing strokes, using a medium badger brush. The tendrils are painted quickest of all, with sure, rhythmic strokes, reflecting the impetuosity of youth.

5 *Pay particular attention to the position of the hand as you paint the vine stroke. Imagine yourself as a skater describing figures on the ice as you go through 180°, and you will have some idea of the movement range involved— sometimes gliding; sometimes pausing before executing a reverse that almost doubles back on itself. Use both center and side brushstrokes.*

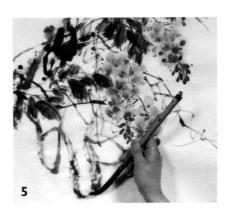

6 *The finishing stages are relatively simple but vital to the success of the whole. Use a dian technique (see Glossary) to emphasize certain points, to provide balance where needed, and to define the space. Dots can enhance the white and change the shape of the space, but do not cover the whole page. Remember to leave some areas unpainted to become significant and asymmetrical spaces.*

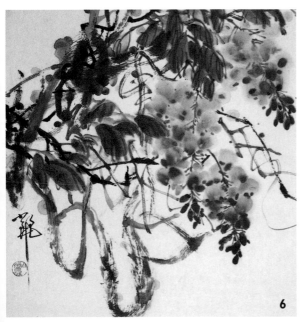

Lotus Blossom Fan

Fan paper is available ready-made but not fixed to the sticks. The texture of the paper and the fact that it has been made up dictates that it is of a meticulous type, so the techniques described for the xieyi method (see pages 72-73) can all be used.

Paint the outline first, gradually working across the surface. A fan composition is not easy to handle but if space is considered all the time, the results are very pleasing. Next color the flowers, working on one petal at a time. The leaves follow and then any other detail such as the dragonfly. There is no need to show the surface of the water provided the plants appear to be growing naturally.

1 *Paint the outline onto the fan paper using an upright brush and minimal loading. Try to create interesting lines and strokes by varying the pressure.*

2 *Add color to the petals, starting with the tip and working the color out halfway down the petal with a damp brush. The surface of the fan is much the same as the meticulous paper, and therefore the same techniques may be used.*

3 *Complete the coloring of the leaves, again working the color with two or more brushes. Use differing colors so that the leaves and flowers do not appear too bland.*

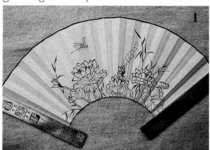

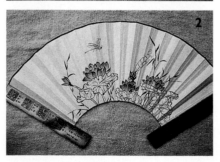

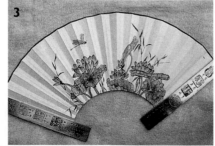

Once finished and dry, slide the fan sticks into the pockets between the two layers and glue the end covers into place. Make sure the fan opens and closes properly, and that the sticks are in the right pockets. Look at the example and you will see that the right-hand cover stick is fastened to the top of the fan, and the lefthand one to the underside.

A detail of the finished fan.

BELOW *The completed fan mounted on sticks. Although fans were used for ceremony and for cooling, they were also used as a painting format. You will often see fans in exhibitions that have never been mounted on sticks, but are still in their flattened form, with or without the pleats or folding. The shape is a difficult one for painting, but very satisfying when complete.*

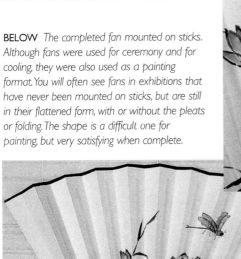

81

Leaves and Flowers

As you have seen, in Chinese paintings flowers have many symbolic meanings. These hidden meanings can be used to add an extra touch to paintings and gifts.

FLOWER SYMBOLISM

Here is a list of the most commonly painted flowers in Chinese art, alongside their symbolic meanings:

almond blossom and narcissus good fortune

azalea, cherry, and jasmine ladies

blue hydrangea wisdom

camellia and plum blossom good luck

camellia and wax blossom hope and endurance

cherry blossom and magnolia spring

convolvulus love and marriage

chrysanthemum fall, retirement, pleasure, October, scholar, hermit, and joviality

day lily mother

early rose winter

flag iris summer

flowering plum longevity, old age, hope, purity, winter, fortitude, January, springtime, and renewal

gardenia November

jasmine and magnolia sweetness

lotus purity, summer, July, creativity, and fidelity

magnolia May

mallow September

narcissus good fortune

orchid many children, piety, beauty, and love

peach blossom February

peony good fortune, riches, rank, spring, affection, and honor

pinks summer

poppy December

tree peony spring, March

yellow hibiscus triumph of summer

FLOWERS: OUTLINE AND FREESTYLE REPRESENTATIONS

On the following pages, there are pictures of leaves and flowers painted by Jane Dwight. Each flower is painted in outline, with an example of the same flower painted in freestyle next to it. Bear in mind that you can always paint freestyle leaves with an outlined flower.

When spring and summer flowers are in bloom in the parks and yards, it is a very good idea to make outline sketches of the different kinds that you see. Try to capture a leaf from different angles and a flower in bud. These sketches can then be used to make lovely paintings on a rainy day in the winter.

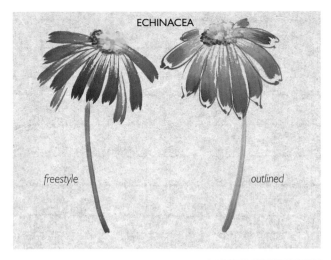

ECHINACEA

freestyle

outlined

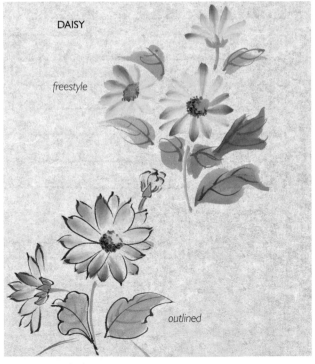

DAISY

freestyle

outlined

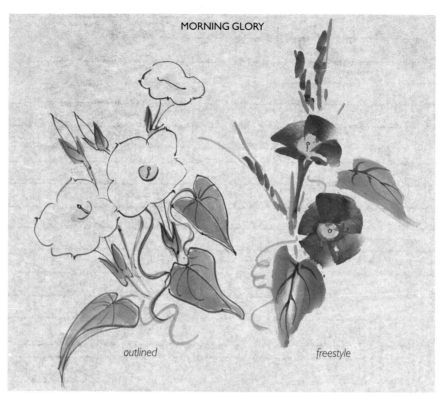

MORNING GLORY

outlined

freestyle

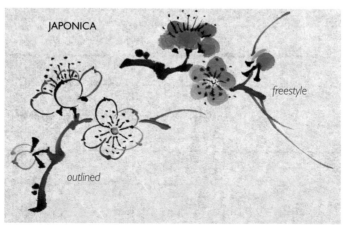

JAPONICA

freestyle

outlined

ORCHID

outlined

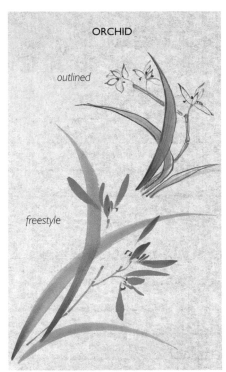

freestyle

OUTLINED
OR
SKETCHED
LEAF

1

2

3

LEAVES: OUTLINE AND FREESTYLE REPRESENTATIONS

OUTLINED
OR
SKETCHED
LEAF

1

2

3

Opposite is another exercise showing how sketched leaves can be turned into freestyle paintings by imitating the shapes and angles you have recorded.

It is important to get into the habit of sketching, as this is the fundamental skill on which your painting will be based. Practice whenever you get the opportunity and, if at all possible, try to draw from life rather than memory.

Poinsettia

A glorious red- and green-leafed plant, the poinsettia makes an ideal subject to paint on a Christmas card. The illustration here is outlined, but this flower is easy to paint in the freestyle method, using the bamboo leaf stroke to paint its red petals.

I *Begin by outlining a group of circles. These are actually the insignificant flowers of the poinsettia. Use a fine brush and medium dark ink.*

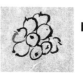

I

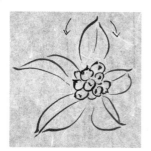

2

2 *The leaves around the center are painted next, using a fine brush and paler ink. Notice that each leaf is given a different size and shape to add interest and realism to the picture.*

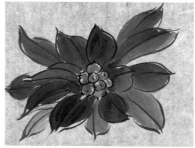

3

3 *Add more layers of leaves behind the initial ones and then paint them all in shades of red. The flowers in the center should be painted in green and yellow.*

4

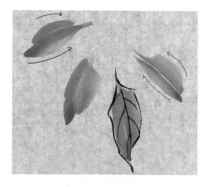

4 *The larger green leaves are painted with a bigger brush, beginning with two freestyle strokes painted next to each other. Fill your brush with green paint and then dip the tip of the brush into red. Pull the brush toward you on the paper, pressing in the middle of the stroke. Finish off the leaves by outlining them with a fine brush. Add the veins in ink, indigo, or red.*

5 and 6 *The branches are added last in brown or ink and woven among the flowers and leaves. This finishing touch ties all the elements together.*

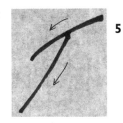

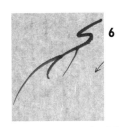

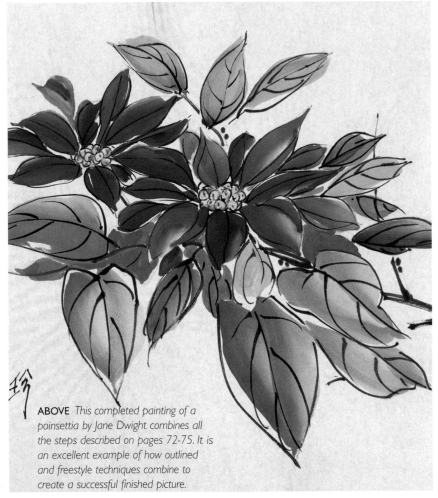

ABOVE *This completed painting of a poinsettia by Jane Dwight combines all the steps described on pages 72-75. It is an excellent example of how outlined and freestyle techniques combine to create a successful finished picture.*

Iris

The iris is a very popular subject. It comes in a rainbow of colors, predominately in blues and purples, with a flash of yellow or orange in the center. A six-petaled flower, it has a distinctive shape, three petals standing upright and three petals drooping, making it easy to recognize and paint.

I *Begin by filling your brush with the color of your choice. Try purple with a tip of blue or vice versa; yellow for drooping petals and deep purple for the upright ones. Paint five strokes by pressing each one on the page.*

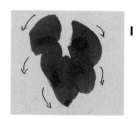

2

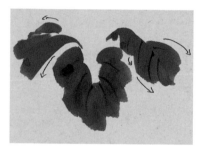

2 *Repeat the process to each side, remembering that these petals will be less full.*

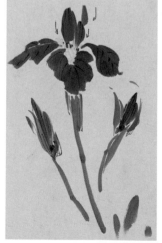

3 *Once the petals are complete, you can add the upright petals and yellow pollen to complete the flower. Add the stalk and buds next.*

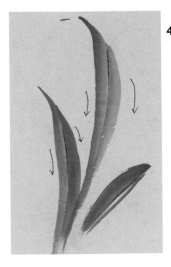

4

4 *The leaves of the iris are generally shorter than the flowers, and can be painted in two strokes. Load the brush with two colors of green (or, if you prefer, green and a little purple) and pull the brush downward in a curling sweep. Add a shorter, echoing sweep to the right to complete the leaves.*

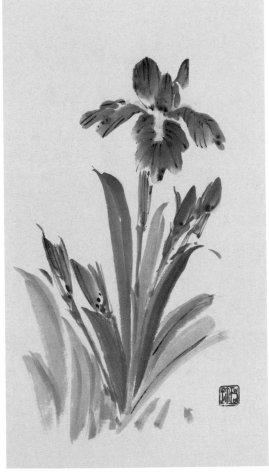

RIGHT *In this completed painting of an iris by Jane Dwight, all of the steps have been successfully combined to create a convincing and attractive picture. Breaking the picture down into its component parts is an essential skill in Chinese painting.*

Creating an Environment

One flower can be used alone as a subject of a Chinese painting. However, it can be difficult to control the composition in a picture based on just one plant. Here, therefore, we combine the flower with a rock, which will give you a solid base and also provide a pleasing contrast with the motion of the blossoms and leaves.

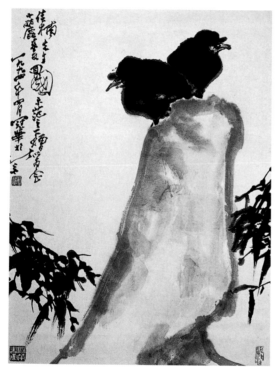

BIRDS ON A ROCK by Gao Guan Hua

A good example of how to put your subject in a suitable setting. The birds are the main subject, with the bamboo as a balancing feature. However, both of these occupy less space than the rock, which is seen as a host to the birds.

Once again the scholar-painters are the originators of this idea, Many scholars were drawn to Lake Tai in the Jiangsu province of southeast China by the beautiful strangely shaped rocks that surrounded its shores. In line with the Chinese idea of endowing natural features with human characteristics, the scholars saw these stones as friends and they became known as "scholar rocks." The emperors took up this veneration of rocks, and after the capital was established in Beijing in the 14th century, they had many such stones transported to the gardens of their palaces, where they recreated a microcosmic south China landscape. The idea of suggesting a huge expanse of natural scenery on a small scale was also adopted by artists. Here we concentrate on the use of the "scholar rock" as an environmental feature in flower and bird painting.

"Scholar rocks" are painted with quick, fresh brushstrokes, and not in the detailed way you would describe them in a landscape, where they are the main image. They are notable for their strange conformations, with holes and irregularities. There are two ways of painting them; you can either draw the rock in outline and then introduce a little color, or you can make the shape using color on a large brush in the *mogu* style and then indicate the contours with ink.

Whichever you use, take care to vary the brushstrokes. Keep the inkwork of the rock positive but underplayed. Remember that the function of the rock is to show the flower to greater advantage and not to overwhelm it.

I *This example reminds you how to hold the brush.*

2 *These four paintings of scholar rocks are by Cai He Ding and are good examples of* xiao pin *painting on their own. Each shows a different aspect and shape for you to observe and copy.*

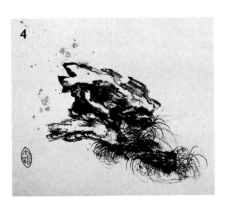

3 *The rocks in these paintings are just like those around Lake Tai in China that so intrigued the scholars and that they later incorporated into their private gardens.*

4 *Notice that each of these rock paintings is a finished picture in itself. You can add suitable flowers and birds to them, although that will, of course, create a different sort of painting.*

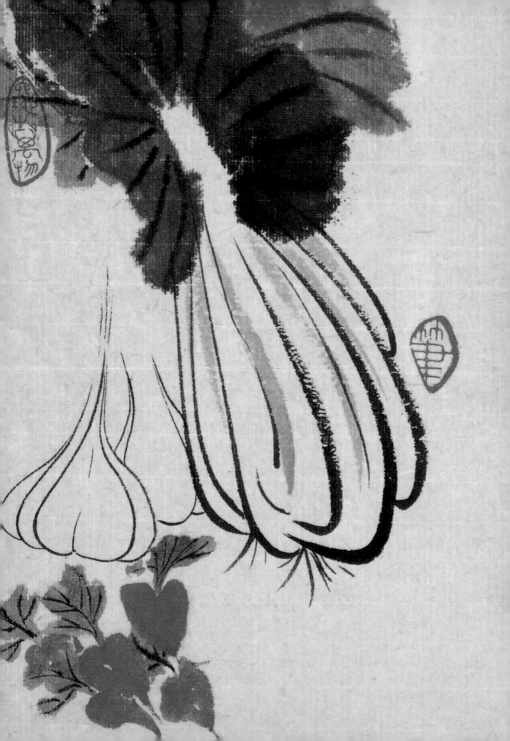

Fruit and Vegetables

The Chinese enjoy painting all kinds of fruit
and vegetables, both arranged on plates and
dishes or still hanging on the tree or plant.
Some artists specialize in showing the bloom
on grapes or a spot of light on the surface. It
seems ironic that the most mundane fruits
and vegetables may be the subject of one of
the most elegant art forms.

Fruit

The techniques employed in painting fruit are similar and usually consist of one or two strokes with a carefully loaded brush.

For single-stroke fruit the brush is placed on the paper with the tip of the brush to the center of the fruit. The brush is moved in either a clockwise or counterclockwise direction, leaving the tip in the center, until a solid circle has been formed. Some artists have considerable skill and are able to leave a small area of white paper to one side to suggest a highlight on the fruit.

BELOW and OPPOSITE *All four of these fruits can be painted with two strokes. Either side may be painted first—experiment to find which is easiest. In choosing the colors try to remain faithful to the original color of the fruit.*

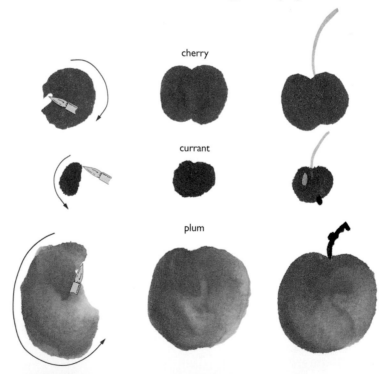

cherry

currant

plum

peach

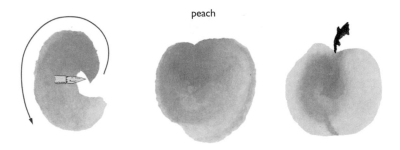

When grouping fruit, ensure that some are closer together than others to achieve a natural arrangement. This is especially important with grapes and similarly shaped fruit.

When using the two-stroke technique, load the brush with a darker color to the tip. The point of the brush can then be placed either to the outside or to the center of the fruit—one method will give a darker outline and is more popular, the other will produce a darker center.

ABOVE and BELOW *Although most fruit will hang downward because of its weight compared to the stem or branch, the composition will be more interesting and true to life if the fruit is painted from different angles.*

Stems, details, and leaves can be added as for flowers. The attitude of the leaves and stems is important to achieve the correct balance. In the examples, different sizes of fruit have been used, from raspberries and currants to peaches.

cherry peach plums

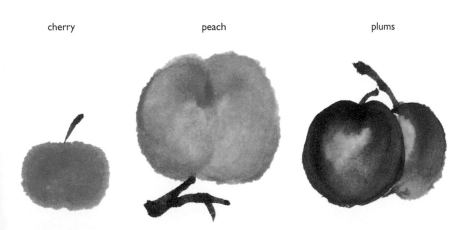

RIGHT *These fruits are completed with one stroke. The tip of the brush is placed to the center of the fruit and the heel taken around in a circle. With careful brush loading, natural variations in shade can be achieved.*

BELOW RIGHT *Fruit leaves should vary in length, width, and perspective. A natural pose and grouping will help the appearance of your painting.*

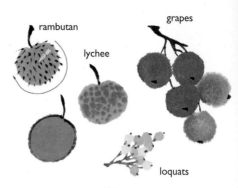

rambutan

grapes

lychee

loquats

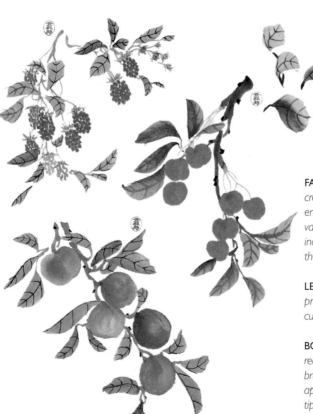

FAR LEFT *Dots are used to create the individual raspberries. To enhance the realism of the picture vary the size and shape of the individual sprays. Try to ensure that the berries look full and juicy.*

LEFT *The stiffness of the branch provides a sharp contrast to the curves of the cherry stems.*

BOTTOM LEFT *Painting plums requires careful loading of the brush. Load the brush with the appropriate color and then dip the tip of the brush into a darker paint. Let the tip of the brush travel around the outside of the fruit.*

RIGHT By placing one cluster of peaches on top of the other the composition is given extra length and perhaps elegance. Because the fruit changes color as it ripens, the choice of shades is wider, allowing greater variation in the composition. Paint the fruit first, followed by the leaves and finally the stems. The seal reads, "Enjoy a little leisure from a busy day."

LEFT As is the case with other fruit, the stems of the lychees should look capable of supporting the bunches of fruit. A more interesting and natural composition will be achieved by placing the start of the branch off-center along the sides of your piece of paper.

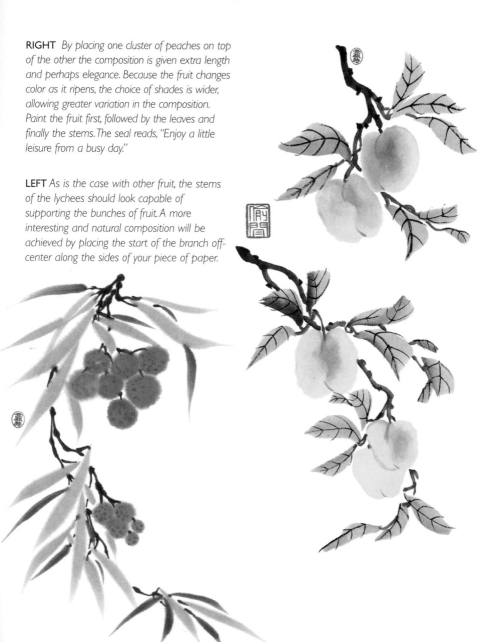

Vegetables

These are also favorite subjects for Chinese brush painting and are used as a sign of plenty. They vary from beans and other similar shapes hanging from the vines, to water chestnuts, mushrooms, and Chinese leaves. The latter appear in many paintings and are often carved on brush pots and other scholars' desk items.

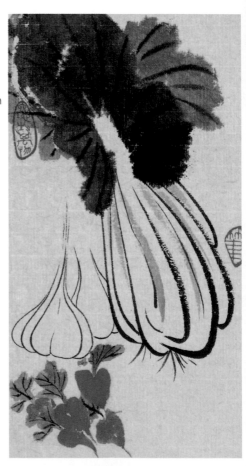

When painting vegetables, try to vary the strokes and ink tones. Both solid and outline techniques should be used to add liveliness, and vary the use of wet and dry strokes. Carrots are painted in a single stroke—starting with the wide end and a sideways brush, gradually moving onto the tip of the brush at the root end.

It is best to treat your copying as a detective exercise, looking for changes in stroke, tone, and repetition to find out how the shape was built up and where the strokes start and end. In time you will be able to look at a shape and know instinctively how to form it. You can then include far more of your feelings about the subject in the painting.

RIGHT *Favorite subjects are often the most ordinary objects. Vegetables, especially Chinese leaves or cabbage, allow the full use of both outline and solid strokes. This painting is on Yuan shu paper that has a rich yellow color. The contrast of the thin and thick strokes has a special impact on this paper.*

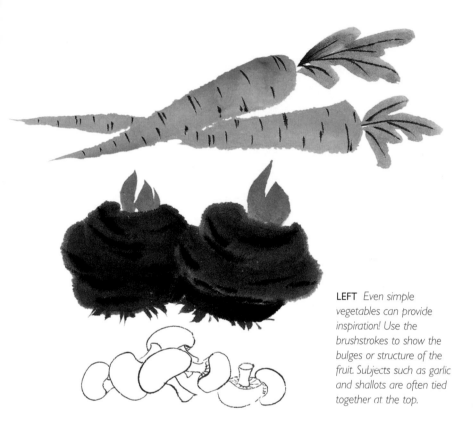

LEFT *Even simple vegetables can provide inspiration! Use the brushstrokes to show the bulges or structure of the fruit. Subjects such as garlic and shallots are often tied together at the top.*

SYMBOLISM OF FRUIT AND VEGETABLES

Fruit plays a major part on New Year's and other special celebrations. Common meanings are—apples (peace), apricots, and cherries (fair lady, April), Buddha's-hand citrons, and oranges (good fortune and immortality), peaches (longevity, spring, and marriage), pears (August), persimmons (joy), plums (hope, January, good fortune, purity, and longevity), pomegranates (fertility, many sons, June, posterity).

Vegetables—fungus (longevity, fertility, immortality), gourds (longevity).

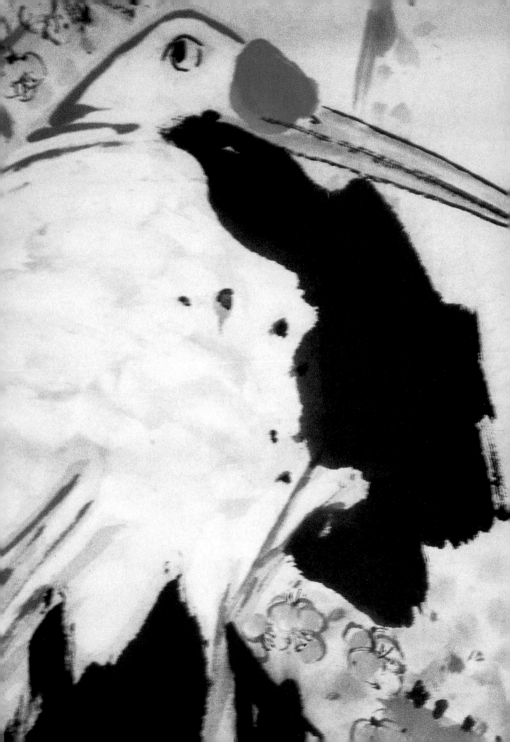

Birds and Insects

Birds and insects are used extensively as subjects for Chinese brush painting. They are used to introduce exotic interest and sometimes humor, and are usually shown with flowers, trees, fruit, and other animals. Birds often have symbolic meaning and more than one theme can be included.

Birds

When painting birds it is important that they appear to sit firmly on a branch or rock, be steady in flight, and, if several are shown, be in different poses to give liveliness to the painting.

Birds are often chosen for their humorous or predatory qualities: they might be bold sparrows, or a large, fierce eagle. The expression in the eye is often used to give the main impact. The artist Fu Hua often uses the eye and the overall attitude of the bird to affect the viewer in various ways. The

golden pheasant by Fu Hua certainly causes a reaction in most people who view it, whether artists or not. Some of his paintings are very large and one has to stand a long way back to appreciate them.

RIGHT *This delightful pheasant by Fu Hua is full of humor and life. Fu Hua regularly paints, demonstrates, and exhibits in England. The color of the rock is unusual and evokes much comment. The simplicity of some of the strokes is offset by the detail in the tail feathers.*

BELOW *Humor is an essential part of many Chinese brush paintings, as these bold sparrows show.*

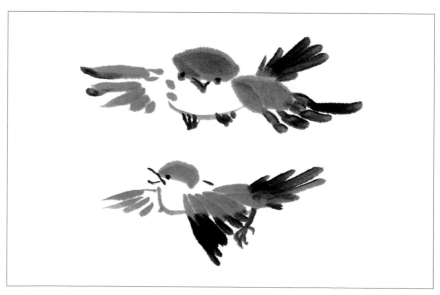

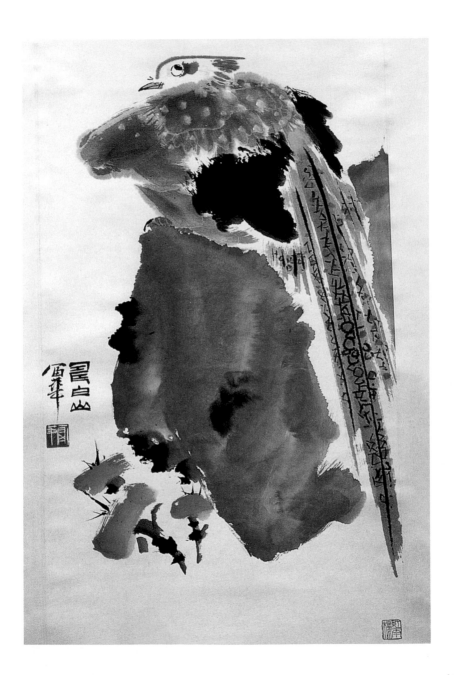

DUCKS

Ducks, especially Mandarin, are symbols of marriage and often painted as a pair or a group. Mandarin ducks are sometimes painted with solid strokes, but the three illustrated are in outline style. Their whiteness can be accentuated by including some background scenery.

Ducks in water are sleek and assured, moving with ease. Ducks on land are awkward and comical, their webbed feet striving for balance. White ducks are mainly domesticated, seen either lazily swimming around or loaded into bicycle baskets and onto the tops of buses on their way to market.

ABOVE and BELOW *Different arrangements of birds can give amusing scenes as these ducks show. Often it is the position of the head or the eye that can almost provide its own caption! A variety of poses of these birds would make a wonderful frieze for a child's room.*

Shape and movement are all important for these ducks. Start with the eye, then the back line of the beak. Next put in the rest of the beak followed by the head and neck. Continue from the neck to the wings, then the tail. The underbelly, and feet are painted last. Finish by coloring the beak and feet.

RIGHT *Freestyle sparrows can be painted in five stages. Use a larger brush for the wings, then change to a smaller one for the eyes, beak, spots, and claws (in that order). Return to the larger brush for the breast and branch.*

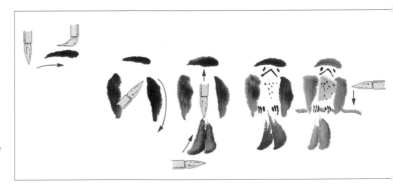

SPARROWS

A very simple exercise to use on a card, say, these sparrows make a cute picture. Just by changing the direction of the beak and eyes you can completely change the character or mood of the bird. First paint a horizontal stroke for the head. Then add two vertical strokes with width in the center (by applying more pressure to the brush), ending with a point at the wing tips. Starting at the bottom of the tail, flick the brush up in two long strokes to form the tail feathers. All these strokes can be in black, gray, or brown ink, as you wish. With a fine brush and dry black ink add the beak, eyes, and feet. A few dots can be added to the breast area followed by a light-colored stroke with a sideways brush over the top. Complete by adding a branch or grass stem for the bird to sit on.

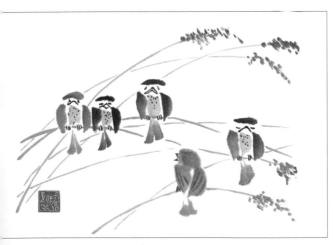

LEFT *Groups or pairs of birds provide interesting subject matter for larger compositions. The expressions can be altered subtly by varying the shape of the eye and the beak*

BIRDS PLAYING IN BAMBOO

I Load a white cloud brush with brown, mixed with a little ink, then dip the tip into slightly darker ink. Use a rounded brushstroke to paint the head and body, which are basically egg-shaped.

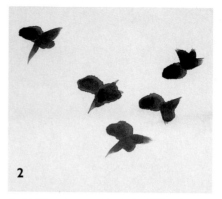

2 Add the wings, pausing before lifting the brush from the paper, thus causing the pigment to spread. This helps to suggest movement. Then add a little dark ink to the top of the head and the end of the wings. Notice that you should already be thinking about setting up the composition.

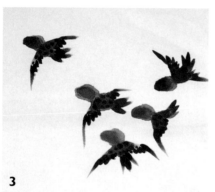

3 Using darkish ink on an orchid and bamboo brush, dab the wings while they are still wet to suggest feathers. Here you are again using the "ink breaking color" technique. Take special care with the strokes at the wing tips and the tail feathers.

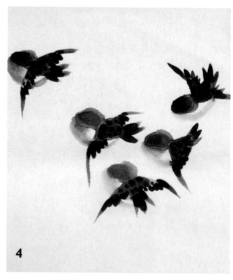

4 Use very light ink to paint the throat and outline of the underbody. The throat is usually gray and slightly darker than the breast, which can be left white.

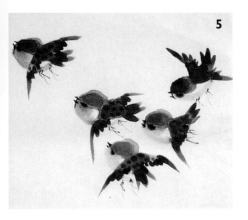

5 *While the pigment is still wet, use very dark ink to paint the eye and the beak using a plum blossom brush. This stage needs a great deal of control, because you must not let the ink run, even though you are painting onto wet. Finally, use a very thin wolf-hair brush to paint the feet. Remember that when the bird is flying, the feet are tucked against the body to make the bird aerodynamic.*

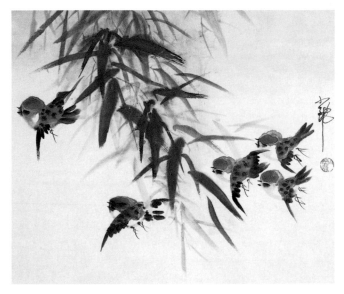

BIRDS PLAYING IN BAMBOO by Cai Xiaoli
A finished painting using the example of the step-by-step. The artist has differentiated between the five birds and used all the shapes. The leader is very strong. The bottom one is struggling hard to follow him through the bamboo leaves. The group of three on the right appear to be in conversation and form an interesting triangular shape. The overall group of birds forms an inverted triangle—an unstable shape that contributes to the sense of flight.

Insects

These are included in many paintings, sometimes with flowers, or fruit. They often introduce an extra dimension into the painting and can also disguise the odd spot of ink on the paper!

Insects can be painted in outline or freestyle. When choosing a suitable insect to include, be sure to keep it in scale with the rest of the painting.

Here we show a wide variety of insects to give you some ideas.

RIGHT *Butterflies look particularly attractive when painted in outline style as these examples show.*

ABOVE *The praying mantis looks almost comic with its huge eyes.*

BELOW *This spider's web by Pauline Cherrett—inspired from more than one source—shows how flowers and insects can be interlinked. In this composition the web serves to draw attention to the spider while the foliage frames the picture.*

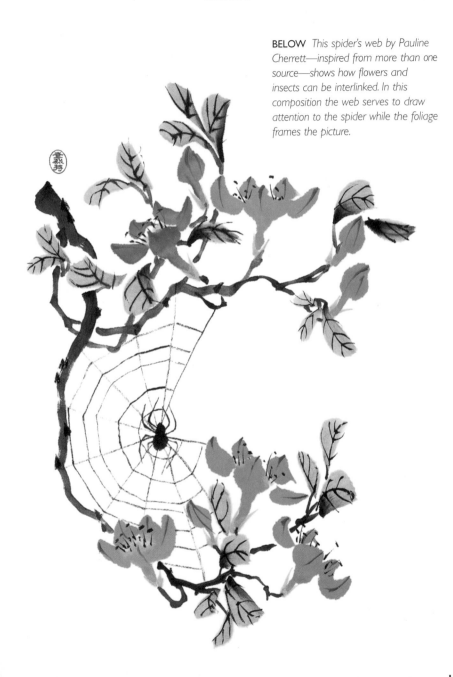

SYMBOLISM OF BIRDS AND INSECTS

Birds used as symbols include rooster (courage, virtue, life force, the sun, and warmth), crane (youth, longevity, good fortune, and promotion), crow (ill omen, filial piety), eagle (heroism), goose or ducks (marriage), kingfisher, pheasant, and peacock (beauty), magpie (good omens), parrot (fidelity), quail (courage), phoenix (peace and prosperity), stork (longevity), swallow (future success). A pair of birds means peace, harmony, and a happy marriage. A pair of peacocks symbolizes business prosperity.

Insects are also indicative of many values—bees (industry and hard work), butterflies (summer, fall, conjugal felicity, joy, good luck, feminine, grace, and light), cicada (eternal youth and happiness), cricket (summer and courage). A pair of butterflies shows nuptial harmony.

LEFT *The wing of this dragonfly is formed from a single stroke and the markings added when totally dry. The legs should be painted with a fine, upright brush and the leaf painted last of all.*

RIGHT *This detail from a painting by Yan Zhen shows how she incorporated the insects into the picture. The minimal amount of detail shown for the insects complements the painting style.*

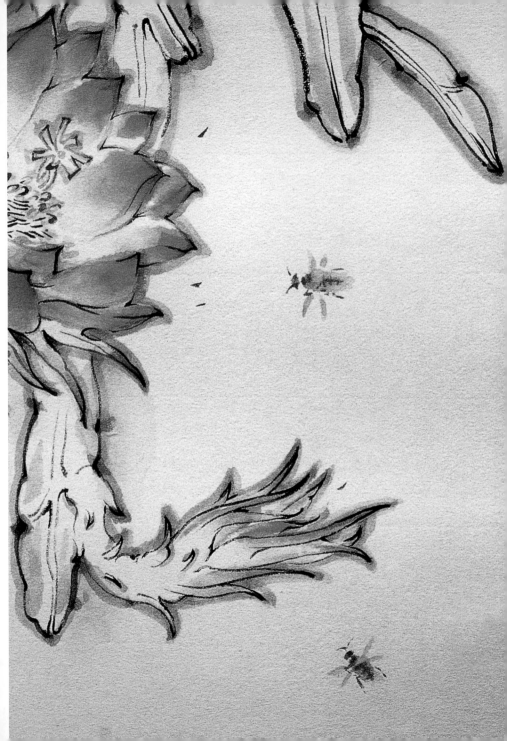

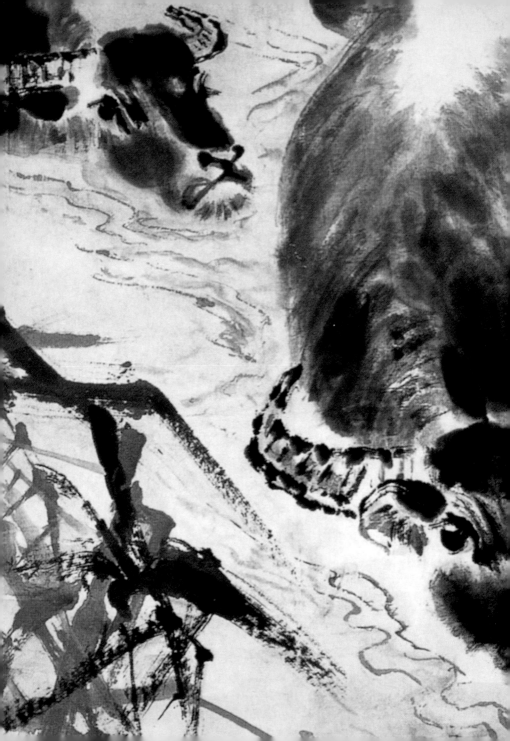

Animals

The classification of animals alongside flowers and birds has less to do with subject matter than with the Chinese view of animals and their relationship both to nature and to people. Animals help to convey meaning about the position of human beings as infinitesimal contributors to some vast cosmic scheme. In this chapter, we take a microscopic viewpoint, and see how animals are regarded within the immediate environment, as part of everyday life.

Dragon

In China the dragon has been used as decoration for centuries, and its correct appearance was a matter of life or death.

Anyone other than the Emperor showing a five-clawed dragon on any of his possessions was executed. The dragon is fifth in the cycle of twelve animals in the Chinese zodiac and referred to as one of the four divine animals, with the phoenix, tortoise, and unicorn.

The color of dragons varies: those depicted on robes were often golden. Chinese dragons are majestic and sinuous—the body should flow across the painting. Dragons are frequently shown chasing the pearl of wisdom.

First paint the head in fine lines, followed by the body and tail. Additional details and coloring are painted last. The main color should be applied in the largest strokes possible; use a brush that

ABOVE *Using a fine brush, paint the main outline, starting with the head. With a mythological subject such as this you can exaggerate some of the features to great effect.*

is too large rather than one that is too small. Never "scrub" the color onto the paper—always use definite strokes, and as few as possible.

LEFT *Color in the dragon with as few strokes as possible, using yellow, green, or red. Add some scales with a fine brush and show the dragon chasing the pearl of wisdom. This design is by Pauline Cherrett.*

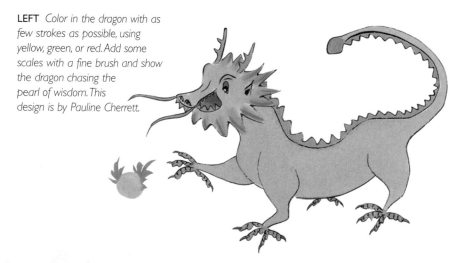

Panda

This is a simple version, not attempting to show too much detail but rather the shape and posture.

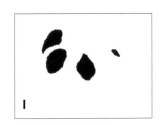

I

The shape of the eye and ear strokes should be imitated as far as possible as these are two of the most recognizable features. The front limbs are not separate from each other in color as the black area continues across the animal's shoulders and onto the other limb. Once the method of painting pandas has been mastered, illustrations and photographs can be used to compose a group such as that shown on the panda fan by Pauline Cherrett.

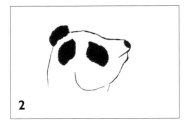

2

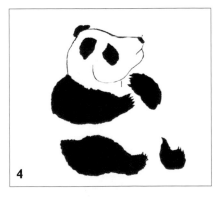

3

I There are five stages to painting a panda. Start with the eye(s), ears and nose in black ink. If painting a group, then show them in different attitudes and angles.

2 Using the point of the large brush, or a finer one, with a little ink paint the outline of the face. Take care not to make the jaw line too distinct.

3/4 With thick black ink add the front and rear legs, allowing the ink to spread for a fluffy outline. Claws can be added and the black markings extended across the shoulders so that the front limbs are linked. Some illustrations and models are inaccurate and do not show this.

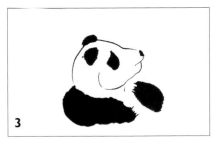

4

5

5 *Finally, add the fine lines for the back and belly, remembering to shade the lower abdomen. To make the picture more interesting, provide some bamboo for the panda to eat, or maybe a rock for leaning against.*

LEFT *This detail of a panda face shows the amount of expression that can be incorporated into the eyes. The shape of the eye patch is quite distinctive.*

RIGHT *Fan paper is not very absorbent; therefore the large limbs of the animals are not so easy to paint. To overcome this a sideways brush has to be used to maximum advantage. As with flower compositions, groups of animals are only really successful when the positions and expressions are varied.*

Water Buffalo

A famous painting of Five Buffalos by Ran Huang, in the Palace Museum, Beijing, shows that animals were painted with as much differentiation of expression as humans. The buffalo ranks with the horse as the most popular animal subject in Chinese painting.

These two animals used to represent the differences between peasant and aristocratic life. The buffalo is still a life-support vehicle for many Chinese living in the countryside. It is seen as hard-working, reliable, and brave. The strokes used for painting buffalo are slow and deliberate to bring out these qualities. The horse, on the other hand, is associated with nobility and speed.

BELOW: WATER BUFFALO by Ou Li Zhuang
Notice the movement of the animals' bodies as they travel in a stately convoy.

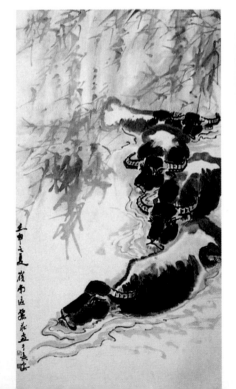

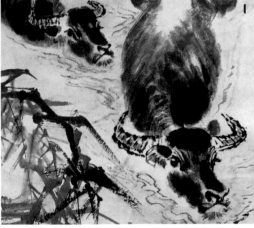

WATER BUFFALO I
This first example shows you how to paint water buffalo.

I *Look carefully at this detailed example above and consider the composition before you begin. If you are unsure you may draw the main outlines lightly in charcoal.*

117

2 Draw the horns, using an orchid and bamboo brush. Do not have the ink too wet.

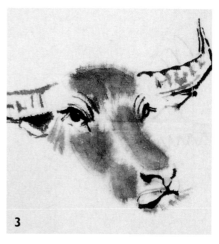

3 Draw the eyes, while carefully controlling the flow of ink. This is the most important feature of animal painting, because, just as in humans, the eyes express most of the feeling. Then, indicate the head with a few strokes, using a soft sheep-hair brush on its side. The ink for the strokes nearest the muzzle should be wetter, and those for the jowls should be slightly dry.

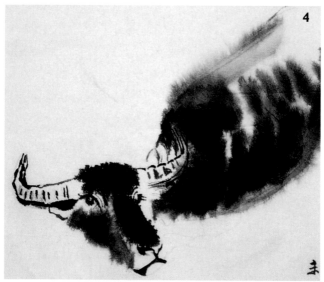

4 Paint the shape of the body with a large sheep-hair brush. Do not make the hide too dense; introduce some light and some shadow. Soften the outline of the body using clean water on a soft brush to suggest the hair.

5 *This shows you how to build up the inkwork on the body.*

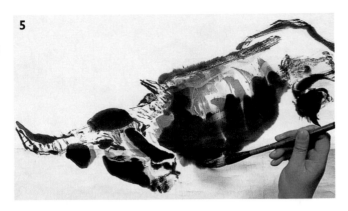

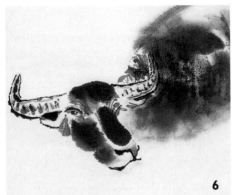

6 *Color the nose, eyes, and horns, if required.*

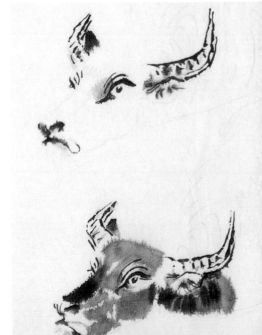

RIGHT: WATER BUFFALO 2
Practice painting the head of each animal in different attitudes, so that the animals will appear more natural when you group them.

Cat

When painting animals the character of the subject should be of paramount importance. An elephant must look very heavy and strong; a mouse small and light. The two main features of a cat painting are the soft coat and the fluidity of movement.

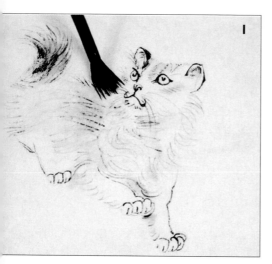

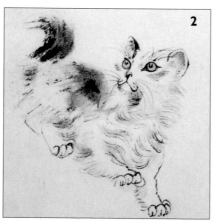

1 Draw the eyes and nose with a small wolf-hair brush. Add outlines, working from the head to the rest of the body. Use a stronger line for the ears, claws, and front leg. Draw the whiskers with a very fine wolf-hair brush. The fur needs a new technique. spread out the hairs of a medium wolf-hair brush with your fingers, dip it in light ink, and use it to follow the curves of the body. Before the ink is dry, go over the body area with a sheep-hair brush loaded with clean water to soften the effect.

2 Use a medium sheep-hair brush to put in some shading. Leave the paper blank where the fur is white. After the inkwork is dry, paint the eyes green or yellow.

3 Practice painting the tail with a flourish, on a spare piece of paper, before putting it on your picture. This is where the qi (see pages 212-213) is transmitted and it must bedone correctly, or the movement will be lost.

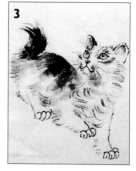

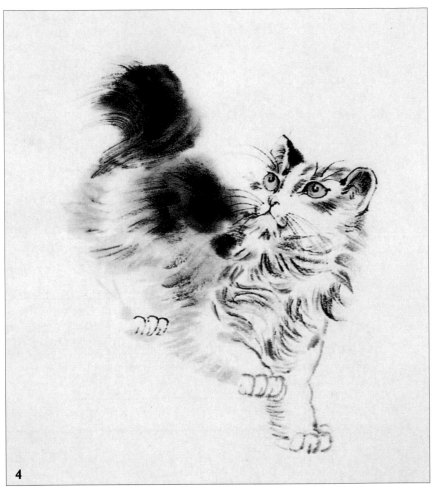

4 Take a long look at your painting to see where additional accents are needed. Leave any good brushstrokes alone. You are now trying to bring out the spirit of the painting. Make sure that the eyes, which convey the character of the cat, are the focus of attention.

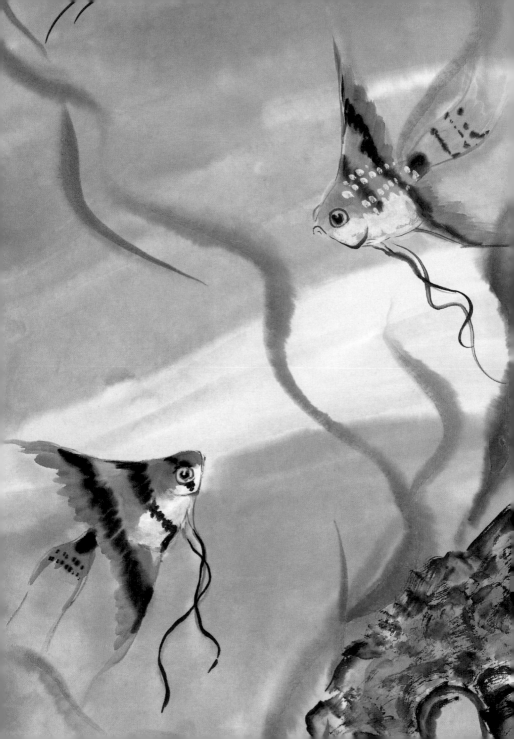

Fish

Fish are highly regarded in China as a subject to paint. The word for carp (*liyu*) is similar to the word for abundance (*yu*). A carp painting, therefore, represents good luck and happiness. Many goldfish are just modified carp, so they too are auspicious. The picture of rainbow fish on the opposite page is by Jane Dwight.

Rainbow Fish

The rainbow fish is a type of carp, but many refer to it as a goldfish. It has the same head as the carp but the body is shorter and fatter. The tail is very long and floats like silk in the water. The wonderful colors it displays (blues, reds, oranges, and yellows) give it its name.

1 *Begin by filling a fine brush with gray ink. Draw the eye and the mouth first, followed by the shape of the body.*

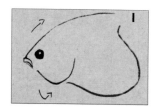

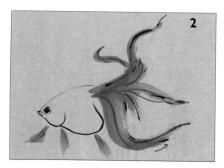

2 *Change your brush to a larger one and dilute your ink to a very pale gray. Fill the brush with this gray and use it on its side to paint long, sweeping strokes for the tail. The fins are painted in the same color but are much shorter. While the tail fins are still damp, add a few darker lines of ink with the fine brush. These represent the supporting endoskeleton in both tail and fins.*

3 *Color the top of the fish with orange, the middle with yellow, and the belly with white, trying to blend the colors together as you paint. Add a dash of deep red to the orange and a stroke of pale blue to the belly for extra life. Pale blue across the top of the eye and a fairly thick white for the scales will finish your fish.*

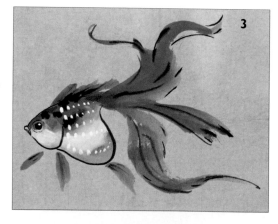

Minnows and Carp

These are freestyle fish painted simply with a bamboo-leaf stroke. They are very easy to create and are ideal for beginners to Chinese painting.

1 Fill a large brush with burnt sienna and dip the tip into ink. Paint a bamboo-leaf stroke.

2 Change to a finer brush and, using black ink, paint the face of the fish on the blunt end of the stroke, noticing the little barbs at the side of the mouth that are typical of many fish.

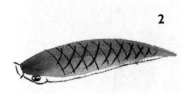

3 Finally, to complete the picture, use the burnt sienna and ink combination once more in order to paint the four fins and the tail.

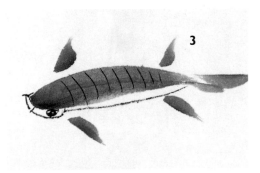

125

The carp is made up of two bamboo-leaf strokes painted close together (see pictures 1 and 2). This gives the fish a solid, three-dimensional shape. Finish the carp much the same as with the minnow (see pictures 2 and 3), remembering to put a streak of white on the belly to give the picture a lift.

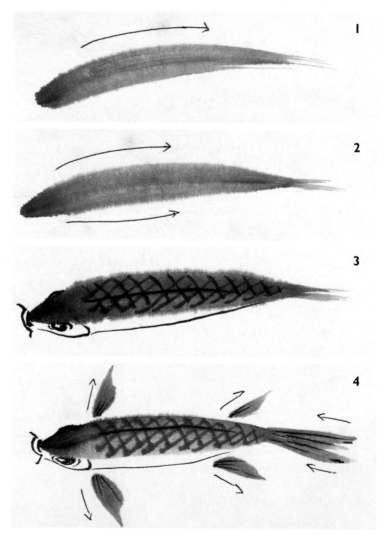

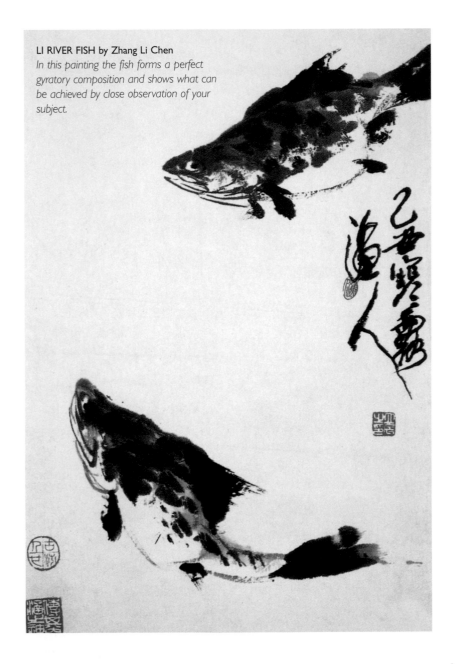

LI RIVER FISH by Zhang Li Chen
In this painting the fish forms a perfect gyratory composition and shows what can be achieved by close observation of your subject.

Crab

These crustaceans are a good practice subject for repetitious strokes!

The examples clearly show how the crab is gradually built up, starting from the center of the back. Using an oblique brush create the back in three strokes; the markings on the shell are formed rather than added later. The attitude of the legs and pincers can be very expressive. You should be aware of the spaces between the crabs and not make them too even.

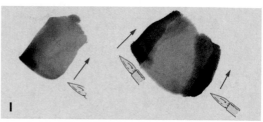

1 *Paint the center of the back. Then add the side strokes, gradually lifting the brush to obtain the triangular shape.*

2 *With an upright brush flick into the body to form the eyes. To paint the claws lower the brush onto the paper gradually and lift it off sideways.*

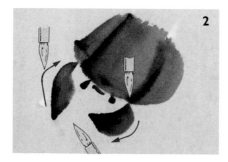

3 *Add the legs, followed by the pincers. The angle between the upper leg and lower leg and between the upper leg and the body should be varied. It is this contrast that increases the excitement in the painting.*

4 Add more crabs to complete the composition, taking care all the while not to overcrowd the picture. This provides good practice at painting legs from all angles!

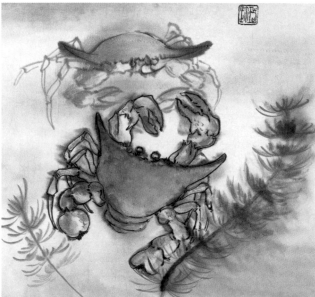

MARYLAND BLUE CRABS by Jane Dwight
This has been painted on absorbent Xuan paper in the style of Henry Wo Yue-Kee. The artist painted the crabs and let the painting dry before re-wetting the whole picture and painting a delicious turquoise blue wash over the top of the subject.

129

Catfish

These fish are the clowns of the aquarium, pond, or river. Capable of great speed if they wish, they often hover or tumble in pairs. Being silt feeders they stay mainly at the bottom of their habitat, occasionally making fast spurts up to the surface.

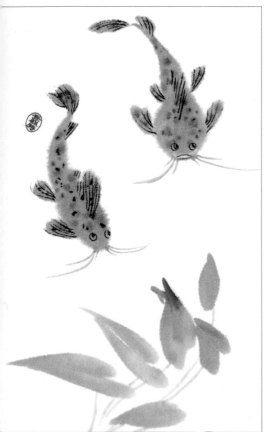

Although not brightly colored, they have spots or stripes to help them merge into the background. They are nonaggressive and friendly.

The first example shows a talking catfish, so-called for the noises that it makes. This is a flat variety with very stiff, spiny fins. Use a sideways brush to make one stroke back from the position of the mouth, then add a stroke each side to give a blunt diamond shape. Using the brush sideways, join the next stroke to the head, lifting the brush onto the tip as you approach the tail. Remember to curve the stroke as the brush travels over the paper. Paint in the fins, fanning outward, making sure that the junction with the body is kept narrow. While the ink is wet, add any spots and stripes so they blend with the body color and do not stand out too much. As the body area is drying, put in the eyes and

LEFT *The head of the "talking" catfish is completed in three strokes (center and sides) and the tail in one stroke. Spots are added while the paint is still wet so that they merge. Again, these fish are full of humor.*

mouth details. This stage can be done first as in the Siamese fighter, but it is sometimes easier to get a good catfish expression if the eyes and mouth are left until later. Finally, add fine lines to show the ridges on the fins and whiskers. Water weeds can be included in the painting if you wish.

The second example shows a different variety, with a more vertical body and less width. it is painted in a similar order. Two strokes for the body (one top and one bottom), then the fins. Body markings follow, then eyes, ridges, and whiskers. Again the water plants give the impression of current and movement.

BELOW *There are several varieties of catfish to choose from. The body comprises two strokes, one for the belly and the other the back. Unusually the eyes and the "whiskers" are added last. These are entertaining fish with much character—this quality should be apparent in the painting.*

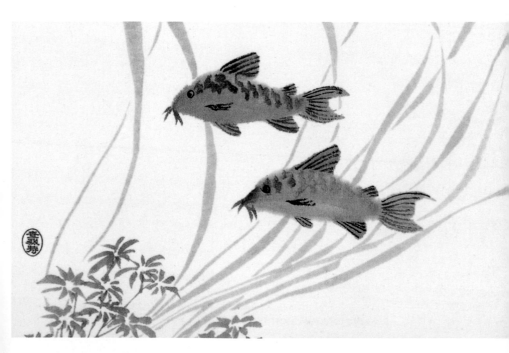

Goldfish

The lower chop on the painting below says "fishes happiness"—referring to a story from 1000 B.C.E., when Zhuang Zi expressed his feelings about fish swimming in clean water. The chop, carved by Qu Lei Lei, uses bronze-age characters (2000–1000 B.C.E.).

This painting is in the Lingnan style and has had a colored wash applied to the reverse. The fish were painted in a similar way to the previous examples (the body in two strokes and the tail in three strokes). The tails are made to appear more lacy and fragile by extending the veins beyond the tail strokes with dotted lines and adding white lines over the basic strokes with gouache. Careful and imaginative brush loading gives the darker line on the back and parts of the tail.

Once the painting is dry, you can apply a wash to the back. With fish as the subject you can also apply a wash to the front to increase the impression

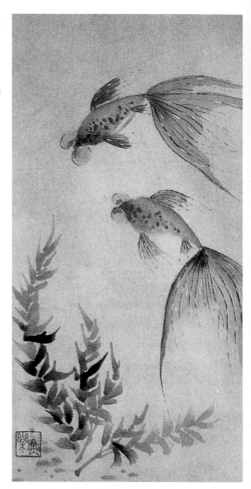

LEFT *This pair of goldfish has been painted in Lingnan style, a style practiced widely in southern China, Hong Kong, and Singapore. Washes of blue and green have been added to the front of the painting, to increase the underwater effect. If this wash treatment had been applied to the back of the painting (as with a flower painting), then the water effect would have been less.*

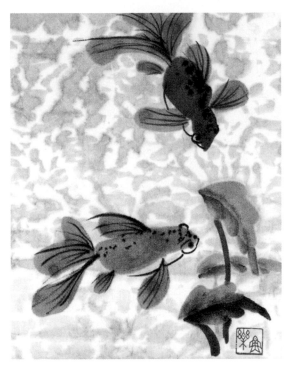

LEFT *To achieve the wrinkled effect of the background the paper is crumpled and then roughly smoothed out again. A large, wet brush is drawn across the paper allowing the color to soak into the high points but not the valleys between.*

FISH SYMBOLISM

All types of fish have fascinating meanings. Any of them can mean conjugal felicity, happiness, harmony, revival, abundance, and wealth, while carp can indicate longevity and help dispel evil spirits. A pair of fish stand for a happy marriage; such a painting would make an unusual wedding gift.

of water. First dampen the painting all over with a brush or spray—avoid soaking the paper by spreading the water well with a hake brush. Then apply the light color. It is easy to add more coats, but you cannot take away a wash that is too dark! The example has a brown wash at the top of the painting, gradually changing to green at the bottom.

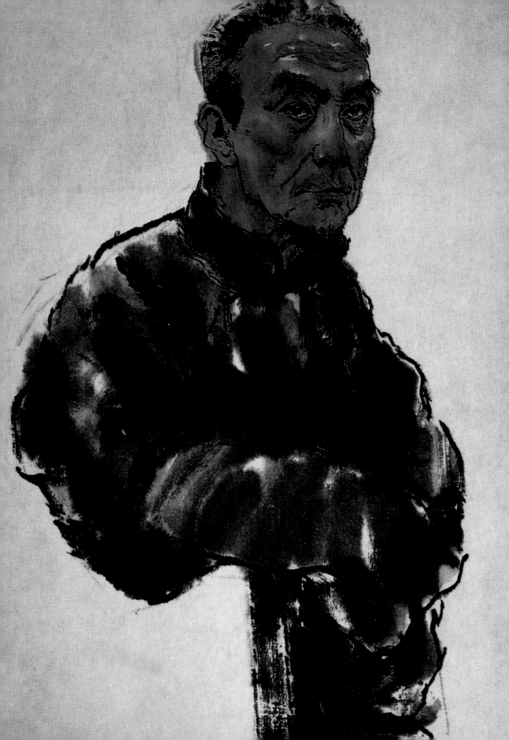

Figure Painting

There was strong interest in portraying the human figure from the earliest of times. On early bronzes men were shown hunting with spears and performing daily activities. Later, religion became a great source; images of Buddha and of gods and spirits from Daoist beliefs were in much demand. Confucian principles were displayed by characters from history and the classics, as well as by morally uplifting examples from everyday life. Portraits of emperors and family ancestors showed their virtues. None of these were done simply to record a likeness of the subject. The Chinese needed to identify with the person in the picture just as much as they did with features of the landscape.

Figure Painting

Like all other Chinese painting, figure painting depends on line. Fine- and free brush styles coexist. As with other subject areas, you must choose the one that is best suited to your intention.

Figures can be the main subject of a painting or add atmosphere to a landscape. Different sizes of figures involve different techniques.

Many figure paintings seen in the West on porcelain plates and in books are carried out by the meticulous method. This means that they are a more realistic, detailed interpretation and therefore more closely resemble Western art. They are often painstakingly colored, with great detail in the folds of clothes and the features.

On the other hand freestyle technique adds liveliness to a painting where the stance and attitude of the figure is often the most important feature, especially in small-scale work. The face and limbs are just hinted at, and the rough shape of the clothes shown. It is the movement that counts.

A favorite subject in landscapes used to be *literati* gentlemen, shown in natural surroundings, either discussing poetry or generally enjoying the closeness of nature. Smaller figures were also depicted, which at first glance appeared to be children, but were in fact servants. Their lower station in life was illustrated primarily by their diminished size.

LEFT: CHUNG K'UEI by Jennifer Scott *is a figure from Chinese legend often illustrated in paintings. The costume is traditional and he is always shown with the same hat and tails.*

LEFT *The Grottoes at Dunhuang, in China's extreme northwest, were one of the most important sources of figure painting. These attendants on a king or nobleman are an exact copy of part of a large mural. The sweeping lines of the calm and dignified ladies influenced the subsequent portrayal of females in Chinese art.*

The other factor that significantly influenced the scale of the figure was the Chinese belief in the importance of Heaven, and the insignificance of man. This belief also accounts for the excess of mounting material above a painting framed in oriental style. It is said that the most beautiful painting is a sheet of white paper, where you can change the image each day in your mind, or indeed escape from this world in contemplation.

There are many traditional subjects for figure painting. The ancient heroes such as Chung Kui, Li Kul, and the gods such as Lao Shouxing (God of Longevity), often feature. Scenes from classics such as *Dream of Red Mansions* have provided inspiration for many paintings. However, one may find one's freedom of imagination limited by the detail of the story and fixed preconceptions held by the viewer.

A better source of inspiration is everyday life in China, which covers such a wide variety of scenery, weather conditions, occupations, and traditions. You will need to study books, calendars, and magazines; there has been a wealth of material published over the last few years, promoted by such a high interest in the East and its culture.

Small Figures

People give extra life to a landscape. They help to provide a sense of scale, especially as one of the main intentions is to instill a feeling of awe in the presence of features such as imposing mountains or powerful waterfalls.

When painting a landscape with figures you will need to decide which to paint first— the setting or the figures. You may find it easier to put in the figures and the foreground first. Do not make the clothes too detailed, but make sure the pose is right. Are your figures looking up at a bird in flight, or at the moon? Are you painting a man standing on a raft with his cormorant, or a farmer following his water buffalo in a flooded rice field? If you are painting the figure with solid strokes, do not make them too heavy. If using outline, keep the strokes rather dry and do not make the lines too even, leaving a gap here and there. Your figure should be standing securely either on a

These figures show the traditional way men are portrayed in Chinese painting. They need to have a suitable action or stance to justify their incorporation into the scene. The colors should be muted and should never dominate the landscape itself, thus reflecting the belief that man is insignificant when compared with nature.

raft or the ground and should have the proper stance for rowing or walking. Gradually add more detail to the rest of the landscape, but try not to overcrowd it.

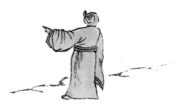

Large Figures

A large figure that dominates the painting requires a different approach. Unless the figure is turned away from the viewer, the face should be shown in greater detail.

One method of starting is to load a brush with a flesh color and paint a "T" to indicate the forehead and nose. The eyes, nostrils, and mouth can then be positioned. In a freestyle painting of a figure, the clothes are suggested rather than shown in detail. Dark trousers or gowns can be illustrated with solid strokes as in the monk painting. The dry brushstrokes help to enliven the work and give the feeling of movement. If painting hands proves to be a problem, your figures could have their hands hidden by long sleeves. Feet are often concealed by a robe.

There are many examples of figures painted in the meticulous style which seem almost photographic in quality. These take a long time and great skill to execute.

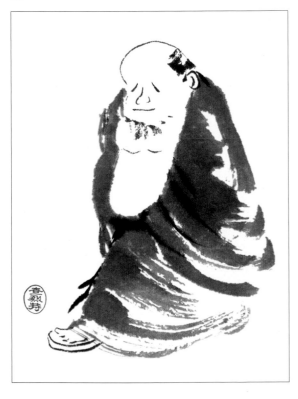

RIGHT *A variety of strokes and ink tones are necessary for* chi *in a figure painting. The painting of a monk hurrying along by Pauline Cherret, is enhanced by the contrast between the dry brushstrokes and the wetness of other strokes in the robes.*

139

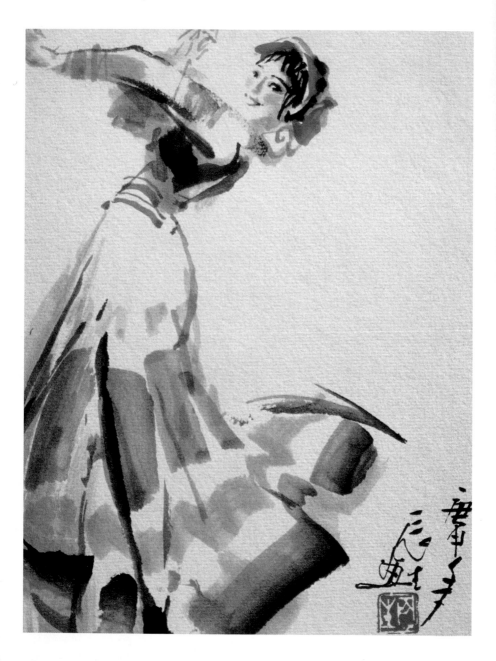

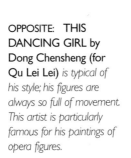

OPPOSITE: **THIS DANCING GIRL** by **Dong Chensheng (for Qu Lei Lei)** *is typical of his style; his figures are always so full of movement. This artist is particularly famous for his paintings of opera figures.*

RIGHT *This figure, inspired by Fan Zeng, is obviously intrigued by the freshness of a spring blossom. Note the lines of the clothes and the irregularity of the strokes. Fan Zeng's style has been simplified quite dramatically here.*

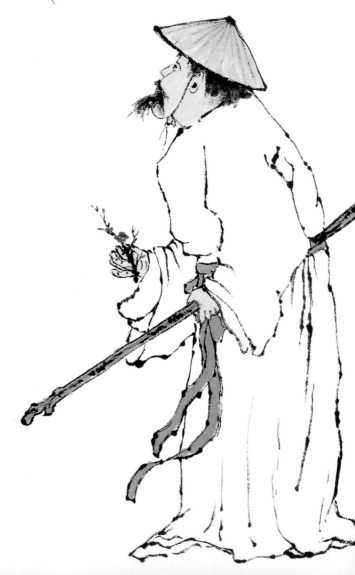

The Jolly Monk

The following two projects show very different figure painting styles; in both, you need to concentrate on the face. We begin with a jolly monk, who is exuberantly declaiming the joy of living.

1 *Start by indicating the position of the head and chest. Then paint the shape of the clothes with energy, using a large sheep-hair brush, loaded with fresh ink mixed with a little glue. Make the strokes boldly.*

2 *While the first ink is still wet, add more ink to give texture to the robe, allowing the pigment to spread. Use a brush loaded with dry ink to paint around the chest in the "flashing white" technique. Start putting color on the face and hands, mixing light brown with a little orange, warm red, and yellow.*

3 *Add the details of face and hands, using a wolf-hair brush and dark ink.*

TECHNIQUES

Figure painting differs from the other types of Chinese painting in one important respect. You should not rely so much on copying examples from earlier ages. Even if you want to paint a subject based on tradition, the image should come from real life.

A painter of people obviously needs to be acquainted with the anatomy of the human body. Our concern here is how to convey the image using Chinese painting techniques. A knowledge of the way the body moves is essential for painting full-length figures, because it will affect the hang of the clothes and the manner in which they drape themselves around the human frame. When painting figures using the minimal brushstroke techniques, every line will be crucial to bringing the image alive.

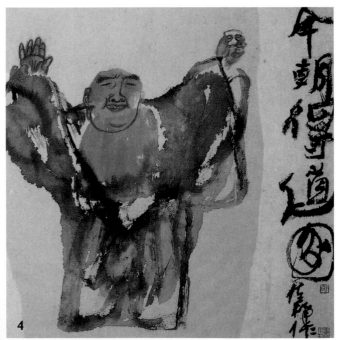

4 *In the finished painting, the full expression of exhilaration is manifest. The brushstrokes are unique, with the calligraphy in the same strong, expansive style as the figure. In this example grass paper has been used, which adds to the heartiness of the subject.*

A Realistic Portrait

When you are painting the human face, the eyes are the key. This has been a precept since a famous master, Gu Kaizlii (345–406 C.E.), said that he often delayed putting in the eyes of his figures for years, because they were the mirror of the soul, and he did not want to get it wrong. The moment you put the eyes in, he said, the painting comes alive.

I Lightly indicate the outlines of the head and shoulders in charcoal. Take care not to overdo this, or you will lose the sense of spontaneity when you draw them in ink. Decide where you want highlights, because these are achieved by leaving the paper blank. Put in the eyes. Add details of the nose and eyebrows.

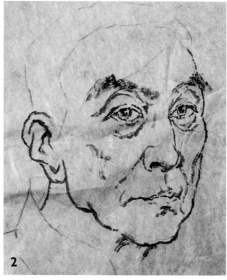

2 Continue with the details of the head, adding some indication of facial muscles. Pay special attention to the individual characteristics of the nose, ears, and mouth.

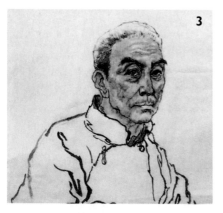

3 Start drawing the clothes, indicating the underlying form by the wrinkles and folds. Begin to color the face, using light brown with the addition of a little yellow and a little ink. Work from the darker areas and shadows to the lighter.

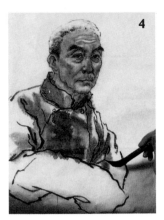

4

4 *Add more color, taking care to vary the brushstrokes. Notice how the blank paper highlights stand out—no white paint has been used. Finally, reinforce the dominant lines with dark ink, where needed.*

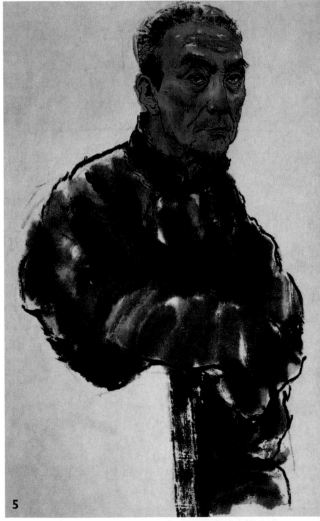

5 *The finished portrait: An effective use of the materials and techniques of traditional Chinese painting to produce a Western-style portrait.*

5

145

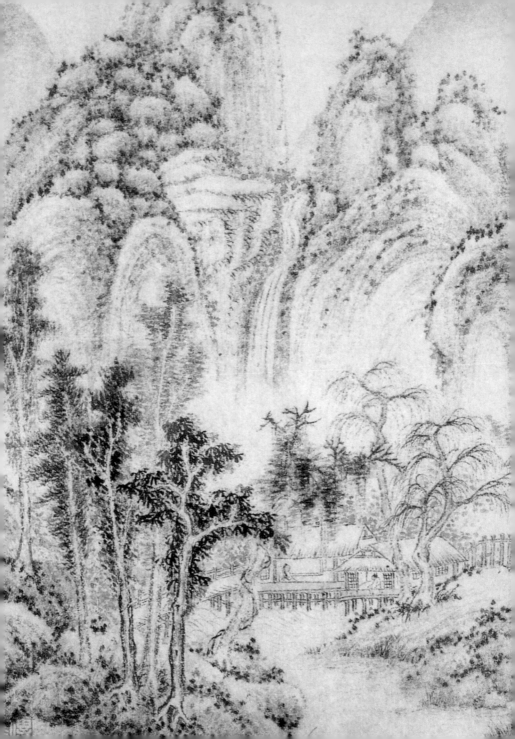

Landscapes

In accordance with the minimalist and symbolic nature of Chinese brush painting, Chinese landscapes are represented by just two characters—mountain and water. These really do describe the essence of most Chinese scenery: the majesty and rugged strength of the mountains contrasts with the fluid nature of waterfalls and lakes. Misty scenes are expressive of large areas of China and often feature in the different perspective views that are so special to Chinese scholars.

Choice of Subject

To begin thinking about Chinese landscape painting, first consider the Chinese characters for landscape. We call it *shanshui*, which literally means "mountain/water." These two features form the structure of landscape painting onto which all else is laid.

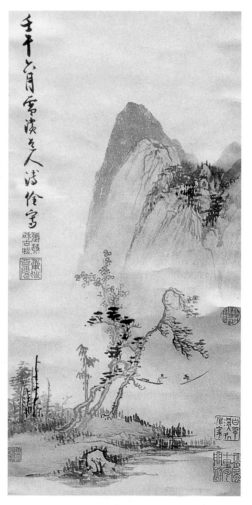

There is a third important element, trees, which may be regarded as the adornment of mountains and water, giving them increased character and definition. The reason why we concentrate on these features is because Chinese landscape painting is not primarily interested in how nature looks, but in how people relate to it. There are, of course, paintings without people in them, but even these are not concerned with a photographic reproduction; instead, the assembling of natural features in a significant way is the aim. Students of Chinese painting do go into the countryside to sketch. However, back

PREVIOUS PAGE *This exquisite album leaf, mounted as a scroll, is from the Ming Dynasty (1368–1644). The brushstrokes in this painting are of superb quality and the traditional style of painting trees is excellent.*

FAR LEFT *This beautiful landscape scroll was painted in 1942 by Pu Chuan, a member of the Qing Dynasty royal family. One of the seals on the bottom right-side means "On my way to a friend, you can see ten miles of clouds and hear the rustle of the pine."*

in the studio, these elements are selected and combined to give the greatest liveliness and point to the finished work. So a picture of mountains can engender a feeling of awe by the sheer majesty of their rendering. This sense of involvement is even more concentrated when people or their artifacts are present: for example, if you put a cottage, a pavilion, or a boat into the picture, you change its focus from a general statement about people's place in the world to the direct relationship of human beings with their environment.

There are two ways to begin your study of landscape painting. First, take a careful look at as many old master paintings as possible; and second, go into the countryside. In China, veneration for ancestors is taught from an early age, and even established artists copy famous paintings. They consider that they have much to learn from their predecessors, and it is also a way of paying tribute to those whom they respect. When students sit with the masterpiece in front of them, they are like apprentices learning from the greatest expert firsthand.

When you go to the countryside, record what you see as accurately as possible. You can do this with a pencil and sketchpad, or in the Chinese way, using a block of ink, a little water in a bottle, and rice paper. The latter has the advantage of obliging you to work more quickly, and you will therefore soon learn to select the essential. Try to "read" the landscape and comprehend the message it is sending to you. Commit what you see to memory, so that you can select from it when needed for your own landscape paintings.

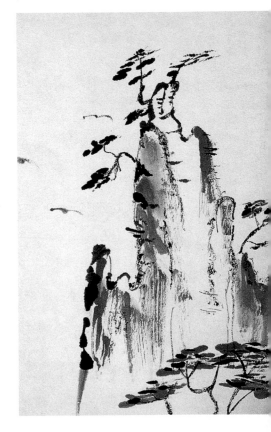

RIGHT *This very restful landscape was painted, after very little tuition, by Brigid Nunan, a physically disabled student.*

Trees

Landscapes consist of two main elements: mountains and water. The tree, however, is an important feature in many paintings. The contrast between the sturdy structure of the trunk and the delicate forms and groupings of the leaves is itself the subject of many beautiful paintings.

Many landscapes feature trees, either in the foreground or in the distance. One suggested guideline is that a tree should have four main branches. Another is that trees are frequently found in groups, one supporting another. Your landscape will appear realistic if the trees look natural both in their setting and attitude. Do not feel that you have to paint foliage on all trees—one or two may have died. Be sure not to include varieties that do not grow in the particular climate you have chosen.

Most people find it easier to start painting the tree from the base so the strokes become lighter as you progress up the tree. There are artists who start at the outer edge of the tree and work inward, but a clear "picture" is required in the mind in order to do this.

A few foliage shapes are shown here, and many more are featured in other books, especially *The Mustard Seed Garden Manual of Painting*—a

facsimile of a very ancient book. In all paintings you should be aware of scale, and this is especially relevant in positioning trees in landscapes. More detail can be used if the tree is large, less if it is shown in the distance.

Trees can feature in figure and bird paintings as well as landscapes. They may form a major part of the work or merely be an accessory.

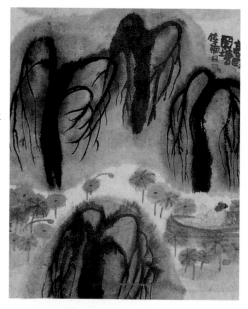

FISHING IN THE LOTUS POND by Wang Jianan
The scholar is closely surrounded by willow trees, which stand sentinel to guard this place.

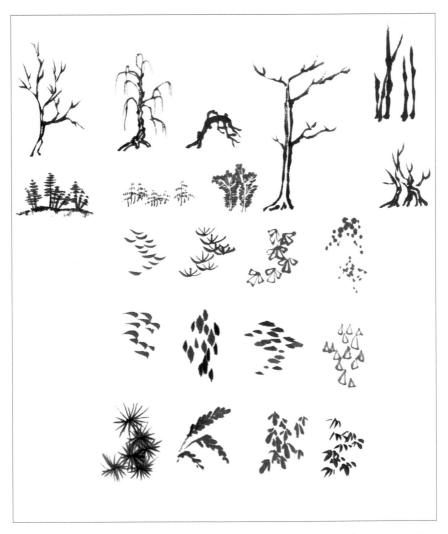

TOP *These tree trunk examples show varying shapes and attitudes. Note the different scale and proximity of the various examples. Distance will always lend an air of mystery to the composition, especially if there are trees or outcrops of rock to suggest something hidden.*

BOTTOM *Leaf shapes and groupings can be varied according to the varieties of trees, the terrain and geographical area being depicted. Comparative scales, however, should be observed so the trees do not appear too large or too small compared to their neighbors.*

1 Concentrate first on drawing the two sides of the trunk, working from the ground upward. Draw one side with a heavier line, reflecting the yin and yang principles. The dark line creates a sense of shadow on one side to contrast with the lighter, more diluted ink tones of the sunlit side. Add texture, using thick strokes to delineate the rough edges of an old tree's bark.

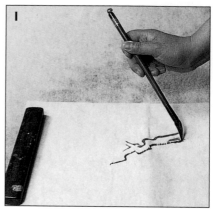

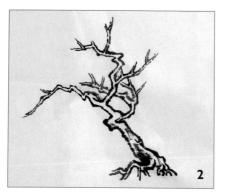

2 Continue building the skeleton of the tree by adding roots and a few gnarled branches.

3 Put in a second, contrasting tree. Paint rocks around the root area and introduce the first leaves. Notice that the trees grow crooked because they are in rocky ground.

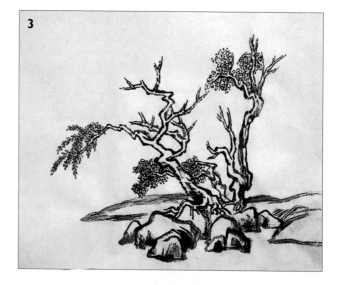

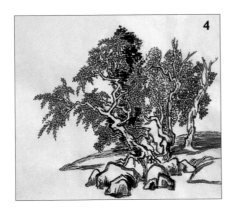

4 *Another tree joins the back of the group, along with a dark tree put in for contrast. This is the opposite of the normal method of placing dark objects in the front, but you can break the "rules" when proficient. Make sure the inkwork is varied.*

5 *The composition is completed by placing different species to the left and behind that adjust the shape of the group. The shading is finished and minimum color is added.*

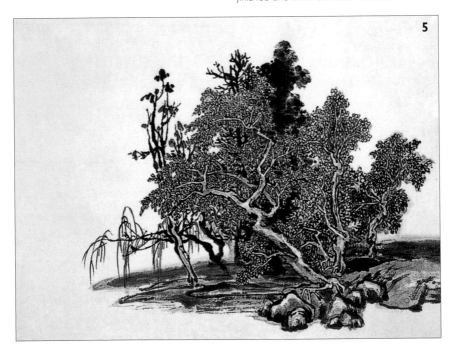

Landscape Fan

This landscape has been painted on a fan. The trees were painted in shades of black, together with the rocks in the foreground, and light gray was used for the distant mountains. The foreground was painted first so the colors could gradually become lighter to give the impression of distance.

Fans are available ready folded and mounted, so that no paper mounting is necessary. The bamboo framework is purchased separately. The paper area is rather like a semimeticulous paper and will take lines very well although it needs care against smudging.

1 First paint the outline of the trees in the foreground, together with the rocks. Fan paper is very similar to meticulous, and will allow fine lines.

2 Color the foreground and background with a light color to suit the mood of the picture. Do not use colors or shades for the background, which conflict with the foreground, as you should try to give depth to the painting. A feeling of depth will be achieved by using different shades of the same color or similar colors, with the lighter color for the background objects.

3 Add additional detail and modeling until you have sufficient objects of interest in the painting.

Once the design has been completed, the sticks can be slid into position and the cover sticks pasted to each end. With care this will give a well-finished look.

4 *This is the completed fan, after the sticks have been inserted into the pockets and the end covers glued into place. The fan can be used for its original purpose, hung on the wall, or propped up on a small stand for display.*

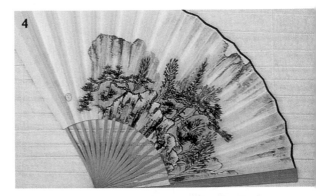

5 *A detail of the completed fan. The fan shape may pose certain problems for the inexperienced painter but the results are worth the effort.*

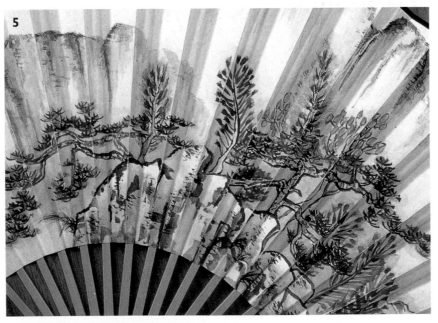

Painting Branches

In Chinese painting you are not trying to make the trunks and branches appear three-dimensional; the emphasis is on the *yin* and the *yang* qualities of the two sides, the sunlit and the parts in shadow.

1 *This painting includes two basic ways of depicting branches: the "deer's horns" accumulate branches in an upward direction; and the "crab's legs" extend downward. Practice drawing them first. Copy the examples, using light ink on a wolf-hair brush to begin, and working up to the darker parts.*

2 *These two types of branches are used to show the different movements in this example. Note the pair on the left, where the dark tree bends behind the white one, which is further accentuated by dots. A little indigo appears in the background to the black tree and the shadow of the small bamboo in front of the cottage. Brown is used on parts of the white trunk and the back of some leaves.*

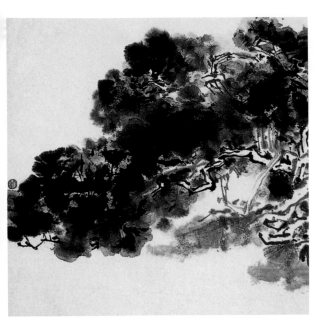

3 *Many tree paintings are left uncolored. The different ink tones are enough to describe all the details. If you want to add color, use it sparingly. It should support the inkwork and not overwhelm it.*

TIP

••••

Always make sure your inkwork is dark enough before adding color.

BELOW *This example shows two ways of depicting the particular characteristics of the pine tree. Notice the needles and the ringlike texture on the trunk.*

BELOW *This demonstrates how to arrange trees. In the group of three, the darker one is placed in front, with another crossing it; that tree also crosses behind the third and inclines toward the pair that are set slightly apart.*

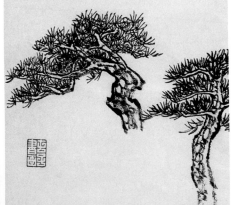

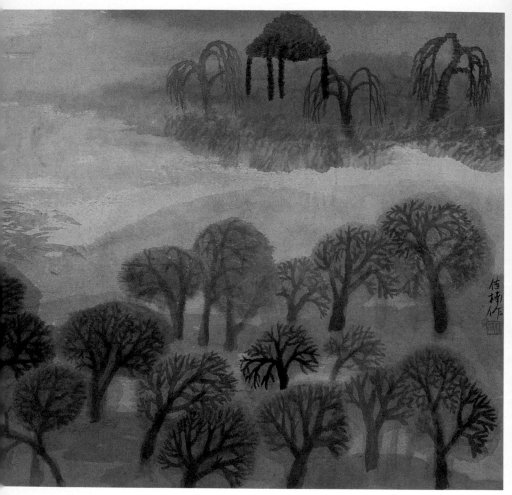

MISTY LANDSCAPE by Wang Jianan

*Depicts a late summer afternoon with rays of fading
sunlight touching every image. Three willows stand close
to a small pavilion, which has an early evening mist
behind it. The trees on either side of the pavilion are lit
from the front, creating an X-ray effect. Their trunks and
branches are silhouetted in ink, and an aureole of
translucent blue-green paint indicates the leaves.*

Mountains

An entire vocabulary of terms has evolved to describe particular strokes used in painting mountains. These pages cover the main techniques, out of the four main ways of using the brush: *gou, cun, dian,* and *ran,* the most important for painting mountains is *cun.*

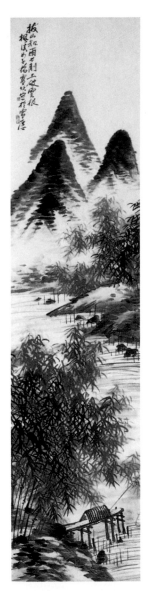

Cun literally means "roughened," but it has become the general term for texturing and shading on mountains. Over the years artists have used different words to describe the various sorts of texture and shadow. These may be divided into two main categories: *pima* and *fupi. Pi* is Chinese for "chop" or "split," and it refers to the appearance of a surface after it has been split by an axe or a knife. *Ma* is hemp; its fibers are strong and when shredded by a knife, it forms interesting threadlike shapes. *Fu* means "axe," and it refers to marks left by the blade on a hard surface. Generally speaking, the *pima* techniques are utilized for mountains that have a covering of earth; the *fupi* are employed for rocky outcrops and dramatic mountain shapes. Along with these two categories of *cun* techniques, *dian* (dots) are used: to give shading. to suggest bushes, trees, and so on, or to add emphasis. Finally, light shading and coloring may be added, using the *ran* technique.

QING DYNASTY LANDSCAPE by Yang Xue Mei
This traditonal landscape suggests recession into the distance by dividing the land mass into three distinct areas (front, middle, and back, and separates them by water. The trees in the forground help to make the illusion convincing. Such a view invites you to go on a journey through this landscape.

PIMA

Figures 1, 2, and 3 are examples of *pima* and all use center brushstrokes.

1 *This is a long thread-like stroke suitable for mountains with a covering of earth.*

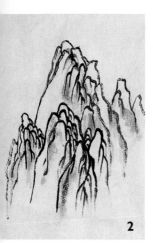

2 *This stroke is more refined than the first. It is called "lotus leaf vein," because it resembles the stroke used for that plant. Notice the delicate ran shading.*

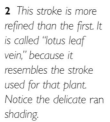

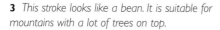

3 *This stroke looks like a bean. It is suitable for mountains with a lot of trees on top.*

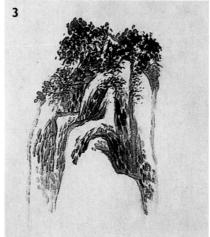

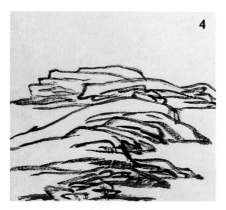

4 *This* cun *is known as "folded ribbon" and is suitable for flat, horizontal rock formations. This type is associated with some covering of earth. Although it is basically a side brush technique, you may need to use a center brush in some places.*

FUPI

Figures 4, 5, and 6 are from the *fupi* group. They are done with a side brush. Start by drawing the outline, then build up the texture.

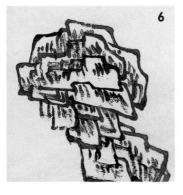

6

5 *Here the axe-cut stroke can be clearly seen. Do not build the texture haphazardly. Every stroke should contribute to the whole and should be motivated by energy. Remember to vary the density of in-filling within the outline frames and to leave some empty spaces.*

6 *This is also a "folded ribbon" cun, but here it is used for hard rock with no vegetation. This is found in some areas of south China.*

5

7 *This is another example of* pima. *The stroke is known as "unraveled string." It is suitable for mountains where there are different textures. It goes well with plants of all types.*

8 *Here is an example of the* mi dot *technique invented by Mi Fu. It is often used for distant mountains and for misty effects. Use a flat brush, fully loaded with ink.*

7

8

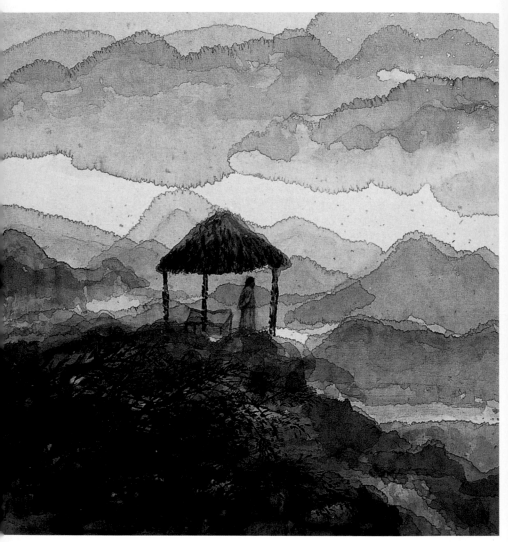

DISTANT PROSPECT by Wang Jianan

Shows how the techniques for distant mountains can be incorporated into an advanced painting. The composition is well balanced. The ink and water were skillfully controlled to give the impression of a deep recession into space.

Rocks

According to Taoist principles, rocks have three faces and there are fascinating names to describe the strokes used to illustrate them. Lotus vein, raveled hemp, axe cuts, and iron bands. Modeling strokes often interlink the structure of the mountains giving each range a unity of style since geology, in Chinese brush painting, changes little.

HUA MOUNTAINS
by He Hai Xia
Here the artist focused on a small section of the range, but he captured the essence of these precipitous north China mountains with assured brushwork. Positive strokes describe the texture of the rockface and the vertiginous clinging trees.

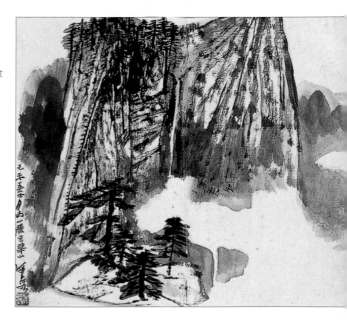

The strokes used should be lively and to achieve this the brush should "dance" across the paper. Keep your wrist very flexible and move the brush from upright to oblique position and back again. Do not paint the mountains as a dominant outline filled in with a few pale strokes—the modeling strokes should all be part of the structure of the rocks.

BUILDING GROUPS OF ROCKS

Rocks are basic to the study of mountain painting and mountains may be considered as the accumulation of rocks. We therefore begin with the smallest unit of individual rocks, using the *gou* technique.

I Think of each rock as having three aspects, which must be conveyed differently, using a side brush. The front part, facing the sun, is dry and rough; the side in shadow is wet; and the top is thin. This gives a three-dimensional effect.

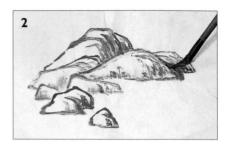

2 Begin to add slightly higher rocks behind, always considering their relationship to the first group. Use the cun stroke to indicate the shadows and define the form.

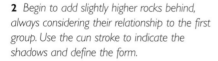

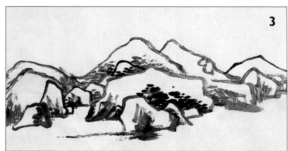

3 As you continue to add groups, bear in mind the need for a connecting line between them. This grouping is in preparation for the actual mountains.

4 The finished painting, with suitable trees added to complete the picture.

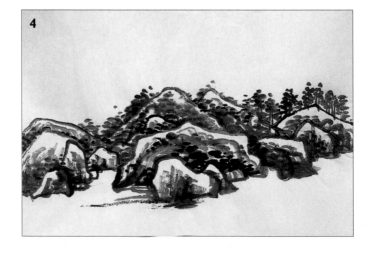

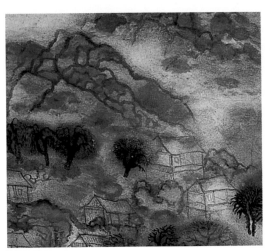

LEFT: SPRING MOUNTAIN
by Wang Jianan
A modern example based on traditional Chinese painting, in which the artist developed the color and techniques according to his personal inspiration.

BELOW: THE YELLOW
MOUNTAINS by Dong Shou Ping
A traditional painting of this area, the brushstrokes used here are completely unlike those in the picture above. Compare the two to see just how distinctive the style of an artist can be.

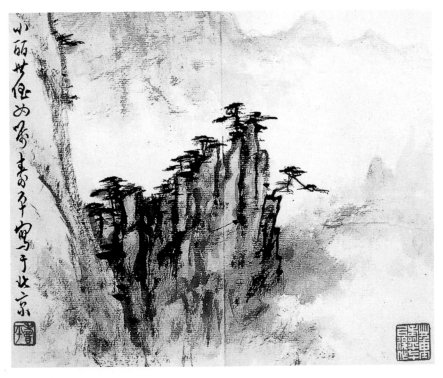

Rivers and Waterfalls

The second most important element in Chinese landscape painting, after mountains, is water. The two elements together help to explain the Chinese attitude to nature. They are *yin* and *yang*, opposites in every way. Rock is hard and unyielding; water is soft and conforming. Yet water can penetrate rock—soft can be stronger than the hard and it's best to let the *qi* (see pages 212-213) go with the flow.

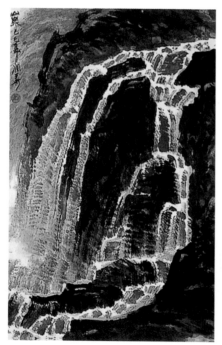

These two principles of Daoist belief are fundamental to Chinese landscape painting, which often depicts a progress or a way through difficult terrain.

Water as the main image in a painting is usually full of movement and dominating. As an accompanying image, it can be tranquil and supportive. In neither case does it depend on the space it occupies in the painting. It depends on the mood and atmosphere you wish to project.

ABOVE: WATERFALL by Huang Ren Hua
This traditional painting uses built-up layers of ink, mixed with a little indigo. No white paint was used on this picture.

RIGHT: AUTUMN RIVER by Wang Jianan
The fall tones in this painting add to the serene image of the river.

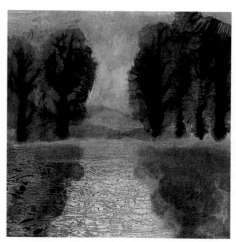

WAYS OF DEPICTING WATER

I *This is one way of indicating calm water. Draw the shapes of the waves with a fine wolf-hair brush, using the gou technique. This method is stylized and decorative.*

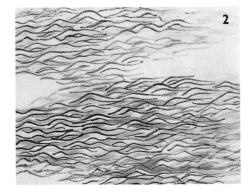

2 *Increase the effect by adding subtle shading, using the* ran *technique.*

TECHNIQUES

There are many different forms of water, and you must consider how best to bring out their characteristics. First you need to understand how water behaves; then decide on the best way of rendering it. Various methods are shown here. Paradoxically, a favorite technique is to leave the water unpainted and to describe it by means of the surrounding images, leaving much to the imagination.

3 *The conformation of the waves needs to be different to show the flow of a stronger current.*

WATERFALL IN A LANDSCAPE

The two examples are of waterfalls with distinctive characteristics. The first is gentle and forms part of a landscape; the second is a torrent that dominates and is the subject of the composition.

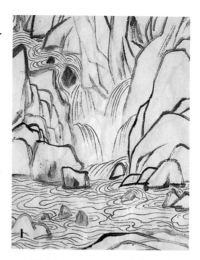

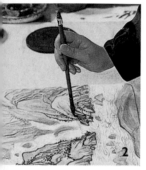

I *With light ink and a center brush, use a* gou *stroke to draw the contours of the mountain. Then begin to trace the water, which forms into eddies. There should already be some differentiation in the inkwork.*

2 *Finish the drawing, and go over the inkwork, using brown and indigo mixed with a little ink, and a* ran *stroke to soften the outlines. Without waiting for the ink to dry, use the* dian *technique to make the structural lines clearer, where necessary.*

Repeat the washing techniques, but paint in different places from before. Use a second brush, loaded only with water, to wash the color well into the paper. Then add contour-reinforcing dots.

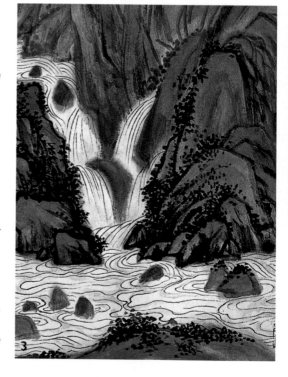

3 *Turn the paper over and use a little watered-down mineral green to paint on the back of the rocks. Do not make it too bright. On the right side, carry out any further adjustments to balance the composition.*

168

MOUNTAIN TORRENT

This waterfall is painted much more broadly than the last. For this type of technique, we say: "Begin boldly, finish carefully."

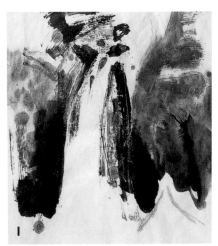

I

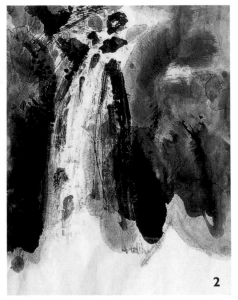

2

I Use both the tip and side of a large sheep-hair brush to put in the main contours, keeping your different groups distinct from one another.

TIP
••••

A more advanced technique that can be used at step one is pomo, or "splashing ink."

2 Soften the ink lines with light ink, as in the previous example. This will help to accentuate the whiteness of the water, which comes from the brilliance of the rice paper.

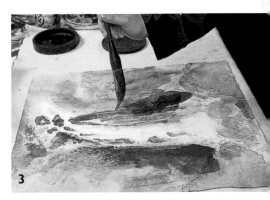

3 Add details using a cun technique and a brush that is half-dry, half-wet. Work more on the rocks at the bottom of the composition, which are closer together, using brown mixed with a little light ink.

3

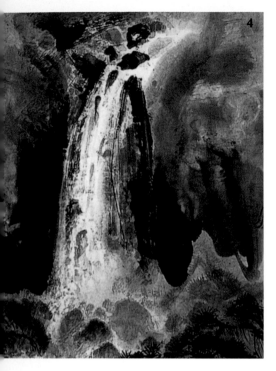

4 *Put in more details, paying particular attention to the rocks sticking out of the water They should be carefully washed to make them more subtle, because the rushing water blurs their outlines. With very light ink, gently indicate the shadows on the water to suggest splashing. Adjust the details. Try to capture the power of the torrent as it falls from on high. The spray should convey the impression of steam. The effect depends on the differentiation of inkwork.*

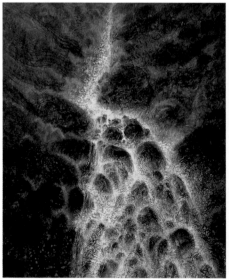

WATERFALL by Wang Jianan
In this painting some white paint was used to add highlights. This artist often paints waterfalls. He sees them as a mirror of his own life's journey. He travels with energy and spirit, but is often impeded by obstacles that he must struggle to surmount.

Composition

The composition of Chinese landscape painting is about the organization of the picture area, and the important concepts are shape, space, and movement. The study of composition is about how the artist relates the first two to each other, and then introduces movement.

The idea fundamental to the relationship of shape and space is once more the concept of the host and guest. Shape is largely the same as form in Western painting. Space, however, is regarded very differently. It derives from the way we think about the pure contrast of black ink and white paper. Even if the painting is colored, we must bear this in mind all the time. Space is not just the areas where there is no image. It has a positive contribution to make, which is why we must carefully control its shape and position. Movement within the picture is often referred to as the "dragon in the painting." A flowing, energetic force. Chinese composition is concerned with ways of putting in movement to make the painting more interesting. Here we suggest how you can relate shape and space and introduce movement to obtain different effects. These are only a selection from many possibilities.

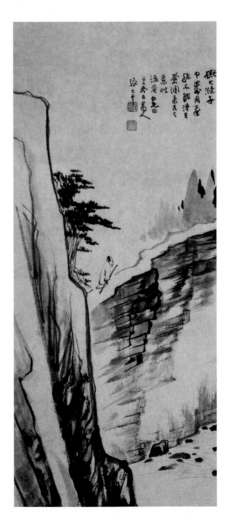

LANDSCAPE by Zhan Da Qian (1899-1983)
Here the two dense mountain elements are connected. Energy comes through the two opposing movements of the looser parts—the river flowing one way and the man wending his way uphill in the opposite direction.

SOURCE by Wang Jianan
The energy is in the water rushing between the two groups of rock.

SHAPE AND SPACE

Two opposing groups in equal proportions

MOVEMENT: Through the middle

The middle space may be filled or empty as in the next two examples. This arrangement has been used since the 10th century.

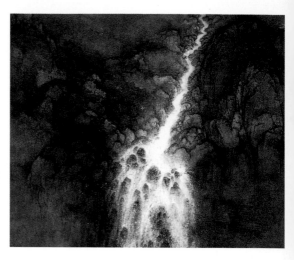

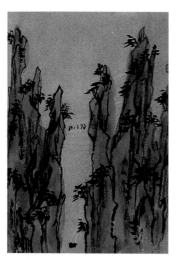

SHAPE AND SPACE

Dense and diffuse

MOVEMENT: Across the picture

In these examples (left and right), the mass of a form is tightly packed against other areas, where there is little substance.

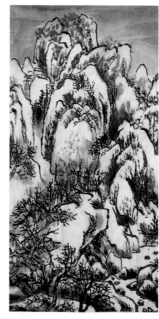

ABOVE: YELLOW MOUNTAINS by Shi Tao

This arrangement appears bizarre by Western standards. The strangely configured mountains seem to confront each other across the gap, where there is a dynamic tension.

RIGHT *This is a study of a painting by Li Cheng, a great master of the northern Song dynasty. The large mass of mountains, with a more freely painted section in front, is a typical arrangement for a traditional landscape.*

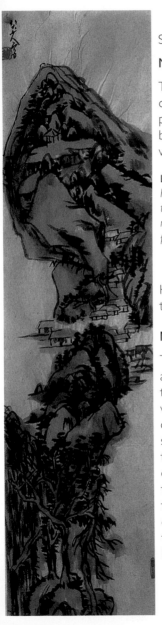

SHAPE AND SPACE
• • • • • • • • • • • • • • • • • •
Solids and voids

MOVEMENT: Various

The balance of large and small shapes and spaces is one of the most enduring arrangements in Chinese landscape painting. Imagine them as white and all the shades of black. Even in a colored image, the forces of black and white prevail.

LEFT *Study of a work by Ba Da Shanren, also known as Zhu Da. He first became a Buddhist monk, then turned to Daoism. During this period, he was at his most creative. Notice how the three major empty spaces and the small spaces throughout the painting are related to each other and to the shapes.*

SHAPE AND SPACE
• • • • • • • • • • • • • • • • •
Horizontal division into three by forms and voids

MOVEMENT: S-shaped

The most popular arrangement for a traditional landscape scroll was in three horizontal divisions, on which this study is based. There are three points on which the eye focuses: the boat in the foreground, the tree-covered middle distance, and the mountains to the rear. This is not, however, an inflexible rule.

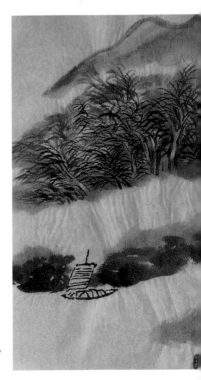

RIGHT *Study of a Qing dynasty landscape.*

173

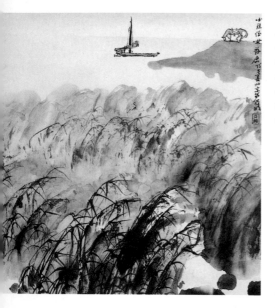

LEFT: ANCHORED by Ya Ming
Another good example of the balance of solids and voids, and black and white. Notice that it is absolutely clear that water is there, without its being painted. This extraordinary composition draws your eye toward the boat. The casual atmosphere is brought out by the grazing donkey.

BELOW *In this study of a work by Shi Tao, the corners are bare. The back areas are left flat, and the scene is pushed to the front.*

SHAPE AND SPACE

Corners and flat forms

MOVEMENT: Various

The importance of the corner began in the 11th-century Song dynasty, when an artist named Ma Yuan left some corners blank "as a means of escape from the Mongolian invaders." He became known as Corner Ma. The practice remains popular. The flat shapes are another way of making a contrast with large mountains.

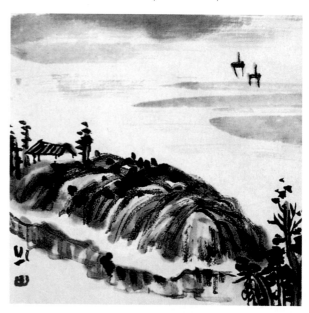

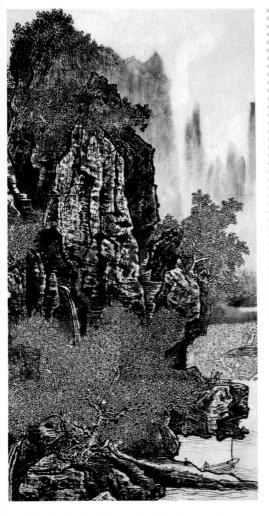

This copy of a Song dynasty landscape by Guo Xi was done by Cal Xjaoli. It balances the bold mountains against a series of flat planes on the right side, receding into the distance. In this arrangement it is difficult to take care of the corners, because of the mountains blocking the way, but the artist was inspired to put a waterfall at the bottom left corner to lighten that area.

Guo Xi (active 1068–1085). He was a brilliant art critic as well as an artist, who worked for the court of the Emperor Shen Zong. He said one should not only admire a good landscape, but live in it.

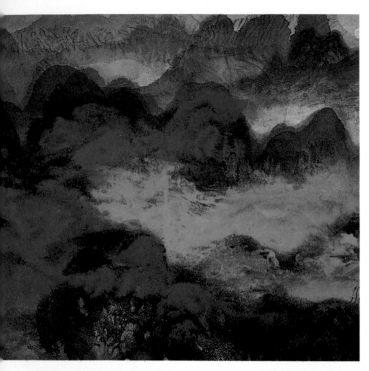

LEFT *This landscape by Wang Jianan is a contemporary interpretation of the "movement across the picture" idea shown on p.172.*

BELOW: SPRING RAIN ON JIANGNAN LAKE by Xu Xi *shows the effective contrast of black and white. This example owes much to the simplicity of woodblock prints.*

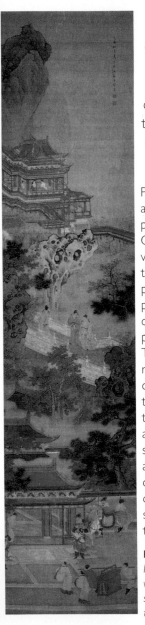

Perspective

Chinese painting uses perspective in a symbolic way. One element in a picture leads to another, without end. By inference, the artist and the viewer are connected to all the life that has gone before, and all that is to come. You cannot see either your ancestors or your descendants from where you stand, but you are aware of their existence.

Perspective, in the Western sense of solid objects being accurately related to one another and diminishing in proportion as they recede into space, does not exist in Chinese painting. However, there are criteria for dealing with three-dimensional forms. The most important is that the viewer must feel comfortable when looking at a picture. A Chinese artist's main interest lies in exploring people's relationship to nature. Perspective is best considered on that basis. To gain the optimum view for painting and for viewing, the artist continually shifts position. Therefore, within a single painting, the artist will take as many different standpoints as necessary to present the complete picture. More than one angle may be chosen and the back and front of objects may be shown at the same time, like a photographer taking a series of shots of a scene, and then making a montage. There are no rules for the selection of viewpoints. Artists organize the elements according to their personal ideas. Another accepted convention of Chinese perspective is that you employ certain devices to suggest height or distance, which are not scientifically accurate. What is important is the impression the viewer receives.

RECEIVING GUESTS by Chen Zhuo

In this painting several conventional devices are employed, no matter where they are, the figures and houses are a similar size. The mist swirling up around the buildings suggests space between one plane and the next.

The Artist

The Artist

The Artist

ABOVE: SHIFTING VIEWPOINTS

An artist looking at several objects in the same painting sees them all from different viewpoints. The artist changes position in order to look at them from a new angle, then groups them in the painting.

The continually shifting viewpoint has two major implications. In Western art you can have a person standing in the

foreground, drawn larger than a mountain behind. This is impossible to the Chinese way of thinking—everything must maintain its correct relationship. Since a person is manifestly not bigger than a mountain, he or she must be shown as smaller. Second, if you want to show a person looking at several objects in the same painting, you must make them all the same size. The person changes position in order to look at them from the same viewpoint (see left.)

One of the first major artists to talk about perspective was Guo Xi, who said that there are three ways to show distance in paintings. The first is *gao yuan* (high distance). This is suitable for stressing the extreme height of mountains. The viewpoint is taken from the bottom, looking up. It makes the mountain appear to be toweringly steep. The effect is gained through shape, not through proportion. The second distance, *ping yuan*, is the flat, horizontal distance already described in the previous chapter. The third method portrays *shen yuan* (deep distance). The observer is now looking down into the picture and will see the high mountains receding into the distance, often changing color as they get further away. Collectively, these three distances are known as *San Dian.* To Guo Xi's three distances, we can add a fourth useful perspective device: *mi yuan* (misty distance). This scene, viewed through mist, clouds, or rain, appears to continue to infinity.

GAO YUAN (HIGH DISTANCE)

This viewpoint from below emphasizes the height of the mountains, giving the appearance of a soaring heavenward sweep. Notice how shape helps to convey the effect.

PING YUAN (FLAT DISTANCE)

This painting entitled *Winter River*, by Wang Jianan, shows the effect of flat distance clearly. Here, the observer is looking straight into the picture from the middle. The flatness of the picture is emphasized, suggesting distance.

A BOUNDLESS WORLD

In the 5th century, Zong Bing wrote in *An Introduction to Landscape Painting* that a 3 inch- (7.5 cm-) high painted mountain is the equivalent of 7,000 feet (2,100 m) in the real world, and that one brushstroke was equal to 100 miles (160 km).

SHEN YUAN (DEEP DISTANCE)

The observer is looking down into the picture. The mountains often change color to suggest different distances from the observer. Use this type of perspective for an atmospheric painting where the colors of the mountains change as they recede.

MI YUAN (MISTY DISTANCE)

A veil of mist, cloud, or rain over a scene creates a special atmosphere, because you can feel but not touch it, and it appears unending. This is a useful way of introducing mood into a painting.

Adding More Character

Man-made objects such as buildings, boats, and bridges are not usually the main subject of a traditional Chinese painting, but their inclusion can convey the character of a region and tell you more about the scene, or highlight essential features of it.

As soon as you put artifacts into a picture, you make a statement about the relationship between human beings and their environment. Buildings have an important function. The Chinese think that a building should both reflect its intended purpose and be fitting for the type of person who is going to use it, as Wang Jianan's picture of the scholar in his pavilion shows.

Boats also serve figurative and informative functions. For example, a ferry means that people are arriving or departing, a cause for celebration or sadness. On a practical level, water transport is central to Chinese life, both for work and pleasure. Not only is the country traversed by three great rivers, but it contains a large number of lakes.

Many towns in China are built near water and to cross a bridge is symbolic of leaving on a journey away from loved ones. It was once the custom to accompany relatives and friends to the limits of the city to bid them farewell, so the bridge was often the scene of much sadness. Bridges were also used as a practical way of crossing deep

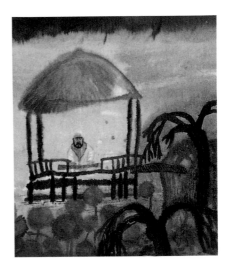

PLAYING THE ZHENG IN THE PAVILION by Wang Jianan
In this painting the scholar's needs are fulfilled by simple surroundings: a wooden structure built over a lotus pond with a roof made of rice grass for shelter.

ravines and other difficult terrain, but since they were man-made, they were seen as a spiritual link between these much-admired natural features. In painting, they carry the *qi* across a space so that the flow is not interrupted.

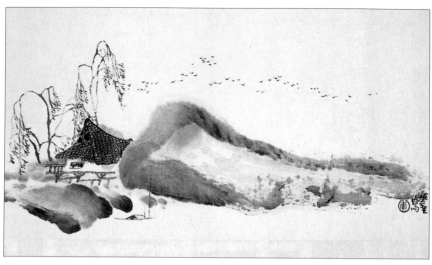

ABOVE: LIVING IN THE MOUNTAINS
by Li Hua Shun
The tent echoes the form of the mountain, showing how closely the owner identifies with the surroundings. The flock of birds and the conformation of the trees also imitate these shapes. This makes for a total unity of idea and image. The brushstrokes reinforce this—a fine wolf-hair brush for the details of the tent, trees, and boat; a soft sheep-hair for the broadly painted mountain.

ABOVE *This example and the next show the level of detail suitable for a village seen in the middle distance. Houses such as these, with roofs made of rice grass, might be found north of the Yellow River.*

BUILDINGS

Copy these examples, so that you can use them later in your own paintings. They show you how to represent and group houses, how to distinguish the types of house encountered in north and south China and how to depict just two buildings in relation to one another.

LEFT *The white walls and black roofs of these houses are more typical of the area below the Yangtze River.*

BELOW *Remember to establish links between buildings. These two double-tiered pavilions are similar but different and stand in a reciprocal relationship to each other.*

BELOW *This example shows you how to paint a group in the foreground. You will need to include more details of the roof tiles and set up the relationship of the houses to the trees. This sort of construction, on stilts over water, is a popular way of building Chinese teahouses.*

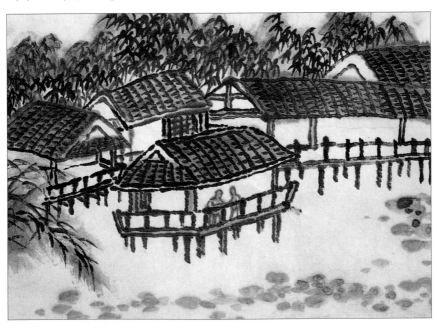

LEFT *An old-style ferryboat. For more control the wrist has to be rested on the table when you paint fine detail.*

BOATS

Here are a variety of boats to copy and learn. When putting them into your paintings, you will need to decide whether or not to paint the water. Often you can leave the paper blank, as in these examples, where a reflection is all that is necessary to convey an impression of water.

ABOVE RIGHT *Although this is a 10th century boat, the shape and method of construction has remained the same until the present day.*

BOTTOM RIGHT *This is a pleasure boat of the kind that a scholar might use. Unlike working fishermen, scholars could look upon sailing and fishing as a carefree pastime.*

LEFT *A similar type of boat designed for enjoyment. Between heaven and the water, the scholar could be at peace with himself.*

TIP
....
Build up a repertoire of buildings, boats, and bridges so that you know them thoroughly enough to portray their essential qualities. Copy the following examples several times and take note of the different brush techniques.

BELOW *A close-up view of a similar boat, with figures, enabling you to study and portray the vessel in greater detail.*

BRIDGES

The bridge in a painting must suit the mood and the location. The following three pictures give examples of different types of bridges to use for varying purposes.

BELOW *People gather on the town bridge to look at the fish in the water below, or simply to lean on the rails and gossip. A strong wooden bridge like this would be at the heart of community life.*

ABOVE *Some bridges are used mainly for decoration and pleasure. Many small lakes in Chinese gardens have a zigzag or serpentine gallery bridge, where friends can meet to watch the goldfish, admire the lotuses, or look at a view of distant mountains. Artists are fond of painting from bridges like this.*

LEFT *This is the typical shape of a stone bridge in China. Here two friends say good-bye; who knows when they will meet again?*

RIGHT: SHOOTING THE RAPIDS by Cai He Ding *Shows the techniques needed to suggest a boat in motion. Here, painting the water is essential to the meaning. The swiftness of the current is conveyed by the way the strokes follow the direction of travel. The urgency is emphasized by the agitation of the water, and even the trees join this headlong rush. The struggles of the poor fisherman are brought out by this precarious voyage on a typical and disintegrating bamboo raft.*

BELOW *The boats anchored along the river in this painting by Cal Xiaoli form an effective pattern of distinctive inkwork against the soft colors of the landscape. The diverse angles of the hulls give an indication of movement, even though the boats are tethered. These are working boats whose fishermen owners live on board.*

Clouds, Rain, and Snow

Approach the effects of clouds, rain, and snow from the point of view of philosophy, which affects the way in which they are rendered. Chinese see the way clouds are produced as one of the continuous self-renewing circuits that underlie all natural phenomena.

Clouds, rain, and snow are all forms of water. Clouds are especially interesting because they represent much of what we seek to convey in Chinese painting. For example, mountains embody the strength, power, and solidity of the natural world; clouds, on the other hand, are apparently weak, docile, and insubstantial. These qualities are the typical antithetical complements of *yin* and *yang*. Yet the clouds envelop or encircle the mountains, changing their shape and character. They are even more rampant than water; nothing can contain them. Clouds are also an important way of transmitting *qi*; they seem in many respects to be the visible manifestation of this energy source.

There are two ways to capture this evanescent form on paper. The first is to leave the paper blank and use the outlines of the surrounding objects to suggest the clouds; the second is to draw the cloud shapes. We already met these methods in the section on painting water, but here the tasks are more difficult because of the flimsy nature of the substance.

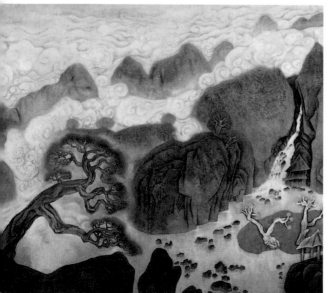

LANDSCAPE SCREEN by Wang Jianan and Cai Xiaoli
All the forms were stylized into decorative shapes, yet the clouds were still used to describe the magnitude of the mountain range.

CLOUDS

A cloud in another form is rain. Landscapes with a rainy atmosphere are popular in China, because they show people contending with the forces of nature and surviving, thus proving their mettle. This battle is both physical and moral.

"The spirit travels through space ... like scurrying clouds kissing the wind" wrote the poet Sikong Tu in the Tang dynasty (618–906 A.D.). The close association between clouds and *qi* (see pages 212-213) makes them an important element in painting, along with rain and snow.

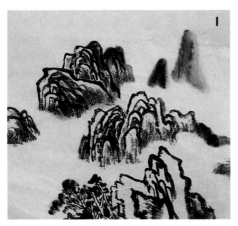

I *This example uses the blank paper technique. Draw the shapes of the mountains with a dry brush in the center position. Add some* cun *strokes for texture, using a side brush. It is important to arrange the relative positions of the mountains correctly so that the* qi *can flow smoothly through. The shape left for the clouds should resemble the sinuous back of the dragon that inhabits this terrain.*

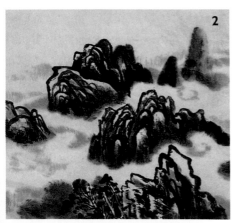

2 *Use a large, soft, wet brush to wash in a hint of the cloud shape, using the* ran *technique. Be careful not to overdo this. You need to keep the balance of solid and void. Remember also that clouds, like all objects whose form is defined by light, have a* yin *and* yang *side.*

189

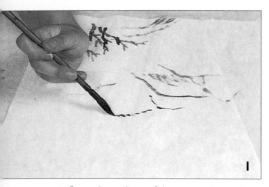

I

1 Draw the outlines of the mountains, setting up the main elements of the composition.

SNOW

Snow completely changes the landscape, in shape, color, and texture. It is most often represented by blank space on the paper, in a similar way to some types of cloud, or by using a dotting technique with white paint.

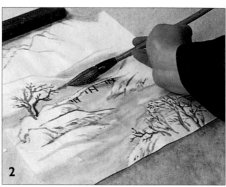

2

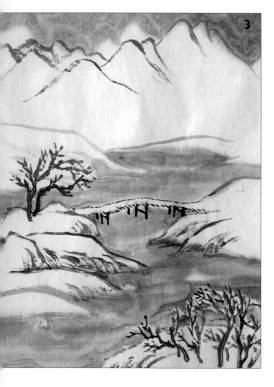

3

2 Using a large sheep-hair brush and the ran technique, indicate the areas of sky and water with the lightest of washes. This is so that the snow on the mountains and the riverbanks, where the paper is left blank, stands out.

3 Add more details of trees and cun the banks of the river.

4 Draw the people on the bridge. Make sure the black ink emphasis points are all in place. Finally, use this technique for the falling snow: Load one brush with opaque white pigment. Use another brush to hit the shaft of the first one, causing the paint to fly onto the paper in small dots. The size of the dots depends on how hard you hit the brush. Practice on a spare piece of paper first.

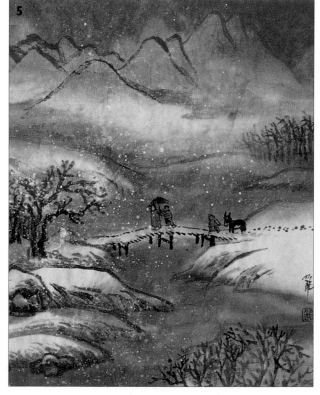

5 Compare the finished painting with the similar composition in the rain project, and note the different atmosphere. The rain picture shows the human struggle against the weather. In this picture, the man and woman are going on an outing to admire the hardy plum blossom.

RAIN

Rain has even less form than clouds, so every other image in the painting must be used to explain its effect. We show one way of doing this in the following step-by-step on rain.

1 *Using light ink, put in the main shapes of the picture. The space for the river is left wide deliberately, so that the man will appear even smaller by contrast, and therefore more pitiful.*

2 *Make the fine marks for the rain by splaying out the bristles of the brush in a fan shape, and touching the paper with the lightest of strokes. Notice that the rain does not fall uniformly, but is heavier in some places.*

3 *The picture has an asymmetrical bias to increase the sense of oppression by the rain and clouds, which seem to dominate not only the man, but also the bridge and the land behind him. Even the bridge appears to conspire against him, because of the low viewpoint that shows the underside of the part on which he resolutely presses forward; the other side is a perilous sheet of water.*

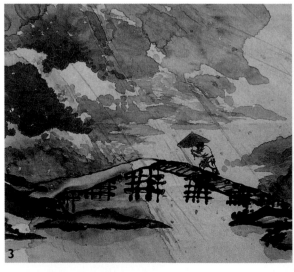

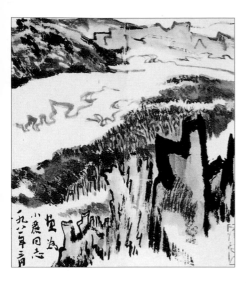

CLOUDS by Lu Van Shao
This xiao pin painting, shows the unique way of interpreting clouds for which this artist has become renowned.

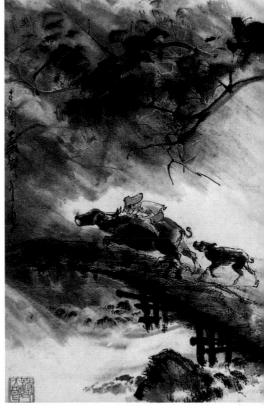

BOY WITH BUFFALO by Cai He Ding
Another way of painting rain. Here the idea comes from the attitude of the creatures in the picture. You can empathize with the boy on the buffalo, with its baby bringing up the rear. The wind and rain almost blow them off the bridge, under which the swollen stream indicates how much rain has already fallen.

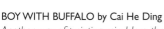

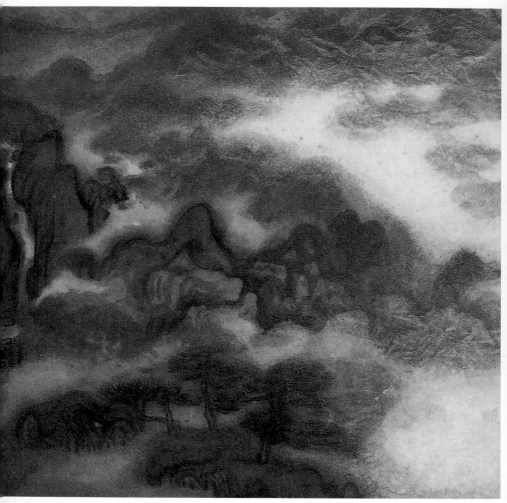

MOUNTAIN CLOUDS by Wang Jianan
*The method of leaving the paper blank was
used to depict the clouds. The painting is
interesting because the blue/green pigments
are those used by masters from the 10th
century on, yet here employed in a totally
modern way.*

Adding Light

Color, mood, and light are inextricably bound together in Chinese painting. Traditional Chinese painting is not concerned with realistic light sources in the Western sense. Nevertheless, there is an implicit awareness of how light can affect the mood and atmosphere of a picture.

The Song dynasty artist Guo Xi said: "The light in spring appears bright yellow, summer light appears deep green, autumn light is pale and subdued, winter light is gloomy and dark." Even without the nuances of the original, we can see that the writer associates the light of spring and summer with the predominating colors of those seasons, but he refers to fall and winter light much as a Westerner would.

To understand the effect of the addition of light, imagine that you are looking at a stage before the performance begins. Then the stagelights are turned on and light floods the scene. This is similar to what happens in Chinese painting.

We can best achieve our purpose by concentrating on the relationship of light to mood. As you know, you must work quickly with ink and paper, and you must think about the whole atmosphere before you start. The particular nature of Chinese colors, and the varying amounts in which you mix them with ink, can give them an intense luminosity. This can be used to suffuse the painting with light rather than introducing particular highlights and shadows.

Western art uses light to describe form. In Chinese painting you learn to paint the three sides of a rock with different strokes. This is a basic way of defining shape, but that is not its main

SPRING PAVILION by Wang Jianan
Chinese colors and the way in which they are mixed with ink can enhance a painting with a magical light. Here the pavilion is bathed in a shower of yellow light producing a warm glow. There is no particular highlight or shadow—the light pervades all.

195

purpose. The intention is to show the light and dark sides, to bring out the *yin* and *yang* duality of the object. Light is often used in Western painting to concentrate the eye on parts the artist wishes to highlight. Chinese artists also have features on which they want to focus. But instead of using light from a recognizable source, they do it through areas of contrast in which the *yin* and *yang* aspects are once again brought into play. Light and dark tones are used in a "host" and "guest" relationship, just like the various elements in a painting.

The purpose of light in a Chinese painting is to give the viewer a heightened awareness of the scene, as the use of special wording does in poetry. Color and mood are enhanced by light in a painting; it is the *qi* of emotion.

Look carefully at Chinese paintings in which light is used to express ideas. Ask yourself whether they give you a sense of the season. Do the colors reinforce the mood?.

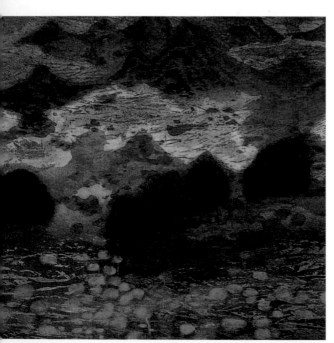

LEFT: LOTUS LAKE
by Wang Jianan *Complementary dark and light,* yin *and* yang *contrasts are used to focus attention on features that the artist wishes to emphasize, and light is conveyed through its intrinsic relationship with shadow. Here, the contrasting colors of blue and yellow are used to suggest a feeling of light.*

RIGHT: AUTUMN LIGHT
by Wang Jianan *Painted using an impasto technique with thick Chinese stone colors. There is no pretense of realism in this painting. The light does not come from one source and the shadows and reflections from the mountains are not accurate.*

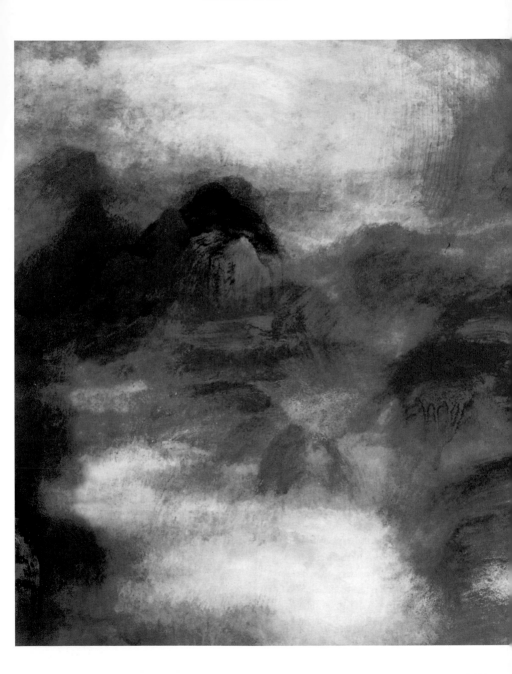

Positioning Your Figures

In Chinese painting all of nature is regarded as the mirror of mankind; to some extent; therefore, the presence of a person can seem superfluous. That is why a figure must always be introduced with extreme care, to reinforce the ideas in the picture and not distract from them.

When the Chinese put a figure in a landscape, it is done for a reason: either to reinforce the mood of the painting, or to show human behavior in the setting. So if figures are present, we need to ask why? According to the Chinese conception, people go to the countryside for one of three purposes: to live and work; to visit and enjoy; or to escape and hide. Figures in a landscape should support these ideas and not overwhelm them by being painted too large or in too bright colors. People give extra life to a landscape. They also help to provide a sense of scale, especially as one of the main intentions is to instill a feeling of awe in the presence of features such as imposing mountains and powerful waterfalls. When we put figures into a landscape, we must consider exactly where to place them.

The people who live and work in the countryside must be painted using different techniques from those who are passing through or are there for recreational purposes. The latter, who include the scholar-painters, should be done with the freest of brushstrokes, emulating their free, individual way of life. The former should be done with a tighter line. The technique of painting the landscape associated with both should confirm their respective positions.

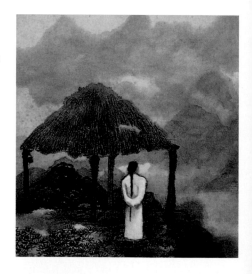

STANDING ON TOP OF THE MOUNTAIN
by Wang Jianan
The scholar is totally isolated from society. As you look at the distant mountains through his eyes, you begin to understand the process of inner purification that he is experiencing.

WORKING AND LIVING

1 Use a small wolf-hair brush to copy this example of a working man, starting with the head. Notice how he leans slightly back and his head juts forward, because of the weight of the baskets.

2 This example shows how you might group the figure below with others. Notice that the clothes of the working men are tighter and more restricted than those of the scholar. The wrinkles in them underscore the rigors of the man's work, while he appears completely relaxed in his flowing robes.

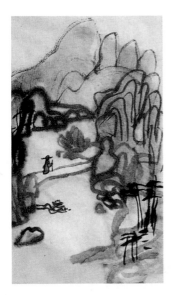

3 When you have practiced drawing these figures with a brush, introduce them into a landscape. Here are some suggestions for placement and scale. The figure must go into an appropriate setting. The hard life of the laborer should be reflected in the terrain; he must carry water up a mountain, for example. The scholar, on the other hand, makes his unhurried progress through a landscape that seems to welcome him in the undulating shape of the mountains.

VISITING AND ENJOYING

1 *This painting by Zhao Wang Yuan shows a landscape typical of the Shaanxi area of central China. In* The Ferry Crossing, *a group of people see friends off on a journey. They are ordinary villagers, so the brushstrokes are simpler than in a traditional scholar-style landscape. Notice how their eyes all follow the direction of the boat, thus contributing to the* qi *(see pages 212-213).*

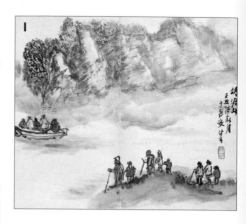

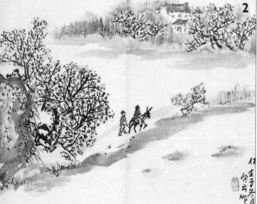

2 *The subject of* Travelling in Spring *is two newlyweds returning home to visit their parents. No doubt the prospect of seeing plum blossom in the snow was an added attraction. Both these paintings by Zhao Wang Yuan have a down-to-earth quality.*

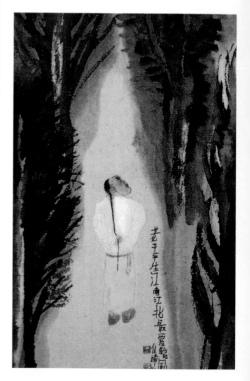

RIGHT: FACING THE WIND by Wang Jianan
This scholar painting shows how strong brushstrokes back up the subject—the figure feels himself to be as strong as the trees withstanding the force of the wind.

ESCAPING AND HIDING

RIGHT *These relaxed characters, engaged in the elegant activity of reading, are painted very differently from their working counterparts. Notice the way that the clothes drape around the underlying forms of their bodies. They are not drawn with much detail, but what there is must be accurate. These figures are models for scholars seeking isolation in remote locations.*

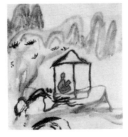

LEFT *Some suitable settings in which to place your scholar. Where you position him is also important, because he will become the focus of the painting. Generally speaking, the best place is slightly off-center; the corners are unsuitable, and the middle should be used with discretion.*

RIGHT: READING IN THE MOUNTAINS
by Wang Jianan *Shows how everything is brought together to describe the atmosphere. The scholar in his remote, straw-thatched hut is surrounded by the water and mountains that he loves. The only link with the outside world is via the fragile bridge.*

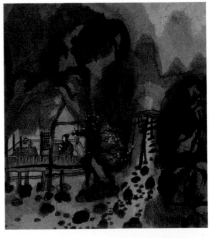

201

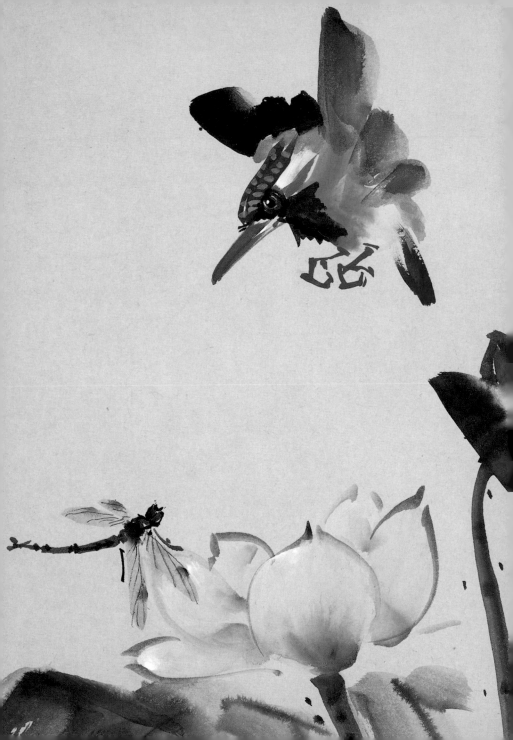

The Finished Picture

Every picture you are pleased with is worth backing. This process, explained next, will flatten, stretch, and strengthen your pictures, making them suitable for framing.

Backing

You will need a cold-water starch paste such as wallpaper paste, made up slightly thicker than the instructions. The Chinese use wheatstarch flour and water heated together to 80°F (27°C), with a few drops of formaldehyde.

You will also need a wide dry brush to remove wrinkles from the paper, one wide and one small pasting brush, a spray bottle filled with clean water, a drinking straw, silicone polish, newspaper, a couple of damp cloths, a dry duster, a piece of dowel or tube longer than the width of your painting, and a piece of the same or similar paper to that used for the painting approximately 2 inches (50 mm) larger on all sides. The work surface can be a formica table, enameled surface, or similar. You will also need a piece of blockboard, plywood, or hardboard (if the painting is small) to paste the painting onto while it dries. You can also use a painted or veneered door that has been varnished. The process will not mark the door as the paste is water-based and can be removed with a damp cloth.

Using the polish, you should make sure the work surface is clean and slippery. This enables the painting to slide easily. Place the painting face down and lightly spray the back with water. Using the dry brush, gently smooth out any wrinkles, working from the center outward. Carefully roll up the painting and set to one side. Wipe the table.

Place the backing paper, smooth side up, on the table, having checked that there are no hairs or spots on it. Again working out from the center, paste evenly but do not be too concerned about any wrinkles. Lift the pasted sheet by the corners and put it down to one side on a dry sheet of newsprint with the paste uppermost. Wipe off the paste brush and go over the pasted sheet to push as much water as possible into the newsprint (but do not be too heavy-handed). Having cleaned the paste from the table, wipe over with a dry cloth, then lay the painting face down again, and if necessary, brush with the dry brush. Lift the pasted paper with one end wrapped around the dowel to support it and make it easier to hold with one hand. Check for hairs and bits! Lower the opposite end gently onto the painting leaving a margin of 2 inches (50 mm). Use the dry brush gently to brush out any wrinkles as you lower the pasted paper. If it goes down badly, lift it off again and reposition. It is possible, even after the paste is dry, to separate the two pieces of paper by soaking, provided a reasonable quality of paper

has been used. Gradually increase the pressure when brushing to ensure that the two pieces of paper are bonded together. With the small paste brush, paste around the excess paper. Tear off two small pieces of newspaper and fold in half. Place this folded paper on two corners of the pasted paper to strengthen the lifting points. Lift the finished product off the table and attach it to the door or vertical board with the painting facing out. Locate the top of the sheet first, then the sides, followed by the base. Make sure that the edges are attached to the door surface all around. Insert the straw and gently blow some air underneath. Leave at least overnight to dry thoroughly.

If the color starts to run (there is less risk with this method as the painting itself is not pasted), wet the offending spot thoroughly with a cloth and blot with clean tissue. When applying the tissue a second or third time make sure it is clean or the color will spread further. The reason for the color running is most likely to be excessive or unsuitable pigment.

When dry, the painting should be very flat, similar to watercolor paper that has been stretched. With a round bladed knife, ease it from the door and trim to size. The whole process can be repeated as many times as you like to obtain a thicker backing. If making a scroll, however, you only need to back with a single sheet.

Alternatively, you can paste the back of the painting with care, removing all wrinkles, and then lower a sheet of thin board onto it (not cardboard as this is made in layers and will separate). After brushing to ensure that all air bubbles are removed, lift the painting carefully and leave face up to dry, before trimming. This method is riskier if you use Western watercolors, and the dry sheet, although it is more substantial, will need to be put under books or weights to flatten for a week. Make sure it is completely dry; otherwise mold may grow on the painting.

LEFT *The Chinese say that no painting is complete without calligraphy and a seal. This calligraphy can be a poem, a saying, a dedication, or simply a signature. Another way to sign your paintings is to have your own seal or chop. This can be a homemade one carved from a piece of rubber, or one of the beautiful stone varieties carved for you by a seal carver. To the Chinese, an artist is also a seal carver, calligrapher, and poet.*

Mounting

The next stage is to put a cardboard or silk brocade mount around the painting. The latter can be done by specialists and some framing shops.

The size of the area around your painting is a matter of personal preference. Oriental proportions are: the width of the painting above (Heaven), two-thirds of the width of the painting below (earth), and a sixth of the width of the painting to each side (showing that you are capturing a moment in time). In the West, people often prefer either the scroll format or equal space all around.

Frames can be of wood or metal. Simple frames will show the pictures to their best advantage; ornate frames may be too distracting. Scrollmaking is a specialized subject and probably best left to the experts. This will be more expensive than framing, especially as silk has continually increased in price. It is also a process that cannot be hurried.

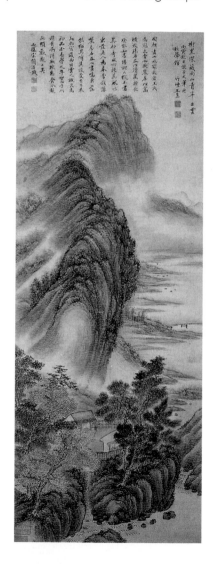

LEFT *This beautiful old hanging scroll by Wang Yu in ink and color is from an exhibition held in 1990 entitled "Escape from the Dusty World," reproduced by kind permission of the Sydney L. Moss Gallery, London.*

Sources of Inspiration

Your eventual aim should be to paint your own subjects without
reference to anyone else's version.

The Chinese feel very strongly about fraud, and if they use another's painting as a guide, they will say "in the style of." This is one important reason for signing or putting your seal on your work, especially as in the West we attach great value to originality. Even Masters who are exhibited by museums include some appropriate calligraphy on their paintings if the work is not their own inspiration. Obviously, if you are taught by someone how to paint fish, for example, your work is likely to have the "flavor" of that person, even when you no longer use their work as inspiration. The Chinese say that even in copying you will always put something of yourself into the painting; you would therefore have to subdue "self" to carry out a perfect copy.

With practice you may find that you need reference for only a small part of your painting, which could come from previous work, or illustrations in books and magazines. It is a way of painting that subject rather than a direct copy.

Exposure to other artists' work is important, especially if you are observant. Decide what you like and do not like about a painting. Look at how they have "managed" the white paper, where the spaces are and their importance within the whole composition. Try a painting

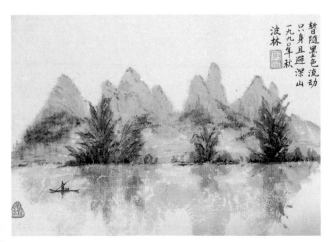

LEFT *This experimental landscape by Pauline Cherrett was inspired by a photograph of the Li River and reflects the words of the poem, "I escape to the mountains along the flow of ink." The reflection was achieved by making the hills very wet and then folding the paper in half. You should be careful not to create handprints when pressing the lower half of the paper onto the painted surface.*

207

similar to the one in front of you, then change the composition or form to suit your taste. When finished you should look at both and ask yourself if you have made an improvement.

Look at both old and new work. Techniques that perhaps do not appeal at first may turn out to suit you. As in all art forms, there are many different styles, far more than are mentioned in this book, and beauty is in the eye of the beholder. You will find that a picture you enjoyed painting will not necessarily be appreciated by others, but your pleasure in carrying out the work is all that matters.

Once you have gained confidence and feel you have mastered the spatial concepts and the minimalist approach, you can branch out on your own and work from sketches, photographs, and real life. The traditional way of viewing a subject was to keep all the details in mind, and often the painting was carried out some considerable time later. Chinese artists seem to "pull a painting out of the air" because they are so familiar with the main features of their subject. Try to cultivate this close observation. Sketches are a way of deciding on the spot what the main features are. Working from photographs will tempt you to put too much detail into the painting. If you are unable to go to China, then photographs, magazines, and films are the best ways to absorb the elements of Chinese life and customs. Of course you do not have to portray Chinese scenes but can use all the techniques to illustrate your own surroundings or favorite places.

RIGHT *This painting was also again inspired from a photograph. Outang Gorge is a dramatic scene and as Yuan shu paper is so yellow, white has had to be added to achieve the mist effect.*

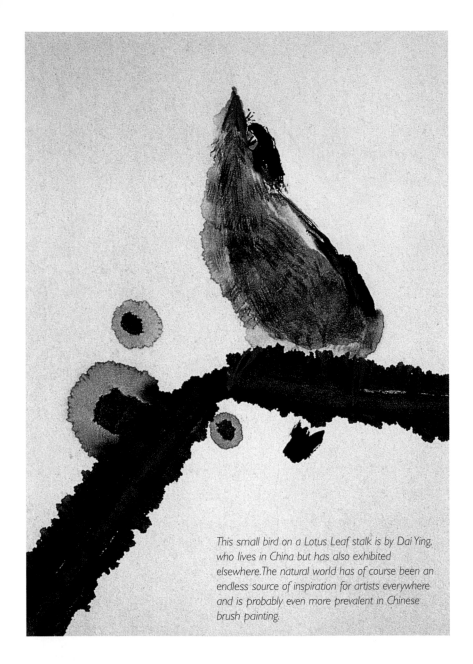

This small bird on a Lotus Leaf stalk is by Dai Ying, who lives in China but has also exhibited elsewhere. The natural world has of course been an endless source of inspiration for artists everywhere and is probably even more prevalent in Chinese brush painting.

Advanced Painting

Once you have started painting, you will find that certain styles and techniques appeal to you more than others. Whatever gives you pleasure is worth pursuing, even if you are not successful initially. But you should not close your mind to other developments in this exciting art form.

The Importance of Qi

Many Chinese believe that *qi* enters your body when you take your first breath. The air you inhale nourishes your vital organs, along with the food you eat, This *qi* is considered to be a life-giving channel in the body, just as much as the arteries or blood vessels.

The concept of *qi* is important in painting and in life. There are many ways of looking at it, and we shall concentrate on three: the *qi* in the human body, the *qi* in nature, and the *qi* in Chinese painting. The Chinese character for *qi* means "steam" or "air," which explains why you cannot see it or touch it; it is a sort of unseen, moving energy.

The *qi* is concentrated in certain nodal parts of the body. In order to use this energy you must focus on them, and develop their potential. One way of doing this is through exercises that help to push the energy around your body and to clear channels that may have become blocked. In addition to physical health, this *qi* is thought to be linked to our mental and moral well-being. Once the *qi* energy is under control, it can be used to great physical effect.

The second *qi* is like the first, except that instead of being restricted to the human body, it permeates the whole of nature. People can identify with this greater energy force, because of their personal *qi*. Human behavior is closely linked to nature's appearance. So, when Chinese people go into the countryside to look at natural phenomena, they are not only admiring the scenery, but also hoping that they will absorb some of the strength of the mountain or the vitality of the waterfall.

Traditional Chinese painting took on some of these ideas centuries ago. Paintings were a vehicle for conveying the metaphysics of nature through the images on the page. Gu Kaizhi (345–406), who was one of the first to postulate theories about Chinese painting, said that "form exists in order to express spirit." If drawing with the brush is the skeleton, and ink and color work are the flesh, then the *qi* is the life force.

Good paintings always have this *qi*. It partly derives from the physical act of painting, but it is also transmitted through a mental image onto the painting, and from there to the viewer. We try to link the various parts of the painting by an unseen conduit of energy, which you can feel, but not precisely see. There are physical ways in which this can be made more explicit, such as using bridges over water, clouds between mountains, water courses from high peaks to low levels, and so on. Links can also be implied. For

example if there is a person in the picture looking at birds flying, the direction of the gaze must follow their line of flight or the *qi* will be broken, Chinese painters try to ensure that the energy is never static.

Another type of *qi* goes beyond the boundaries of the picture frame and back in again. This is why we often paint only part of a branch or tree; in such cases, the energy goes out of the picture, linking the artist and viewer to the physical world beyond, and also attracts energy from that world into the painting. Just as in *Tai Ji* exercises people watching should be able to follow the patterns, see them begin, develop, reach a climax, and then subside into a resting position, before taking up a movement in another direction, so the viewer of a Chinese painting should be able to follow the movement, even when it goes out of the picture frame and returns. It is barely perceptible but undeniably there. It must be controlled and not dissipated.

We also use *qi* in combination with the idea of *yun* in Chinese painting. *Yun* means "charm" and "good taste and refinement in literary pursuits." It refers to the style and atmosphere of a painting. In this case, the energy is charged up and bristling with a nervous excitement, which generates an atmosphere over and above what we see on the paper.

COLOR
QI OF LANDSCAPE
by Wang Jianan
The moving energy of qi may be transmitted through the voids, through the solids, or even through the colors of a painting. If the line of energy is blocked, then the qi will be interrupted.

Resist Techniques

Some Chinese artists living in the West have used a combination of Eastern and Western techniques to explore new possibilities. Even if some methods have a close relationship to forms of Western art, the behavior of the paper and the quality of the brush will always add a new dimension.

This has an affinity with batik. It is especially useful with suitable calligraphy. To achieve this effect, splash milk on the paper (the higher the fat content the better), and write the character over the top. Experiment by letting the milk dry before adding the ink strokes, by painting on the other side of the paper from the milk and by varying the ink tones. The ink and strokes should echo the conditions and the subject—wet strokes for a poem about rain, and dry strokes for one extolling the virtues of living in the desert.

Equally effective are thin staggered milk strokes painted diagonally across the painting with the character for rain or fountain. Once you have tried this with calligraphy, use the technique with a landscape or a figure under an umbrella to suggest a rainy scene.

You can achieve different effects either by putting a wash over the work and splattering with tiny spots of white gouache, or by splashing the gouache on first and then applying the wash.

LEFT *Any characters or scenes can be used but the painting will have far more meaning if appropriate subjects are chosen. The character for "snow" was selected to demonstrate the milk technique. The texture on the paper reinforces the theme.*

BELOW *The character for "snowy" by Qu Lei Lei used with the resist milk technique. This uses the principles of batik to provide a resistance against penetration by the ink.*

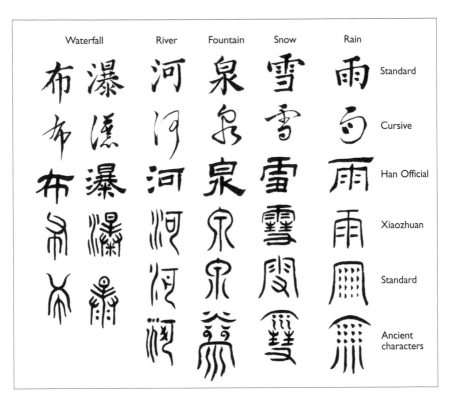

Waterfall		River	Fountain	Snow	Rain	
						Standard
						Cursive
						Han Official
						Xiaozhuan
						Standard
						Ancient characters

BELOW *This simple landscape demonstrates the use of milk strokes to imitate rain. Avoid using too many lines or spacing them too evenly. Dots of milk could be used to give the effect of snow. These could be sprayed on using a fixative sprayer.*

ABOVE *These calligraphy examples by Qu Lei Lei are all suitable for the milk technique. It is a useful exercise to persuade artists to practice calligraphy and demonstrates the difference between the varying styles.*

215

Wrinkling

Wrinkling is used to provide texture. Crush the paper to be used into a ball. Smooth out the paper and gently run a loaded brush over the high points. On the mounted work the creases disappear and the texture remains.

This is a very modern technique inspired by Qu Lei Lei that can be used effectively for trees. This uses a modest amount of wrinkling, and the application of light colors such as stone green on the front of the paper and darker colors, indigo and black, on the back. Putting another color on the back not only throws the lighter color into relief but also pushes it back out of the paper. When mounted, the colors may run, but this will add to the general effect.

This technique is shown in several stages, involving not only the wrinkle method but also the blotting technique.

1 Crease the paper as required. This technique often benefits from not having too many preconceived ideas and just to "let it happen." This is one advantage of an art form that does not use expensive surfaces to paint on

2 Run a dry, black brush along the creases to form trees, etc. The amount of ink and the depth of color will depend on the desired effect and individual taste.

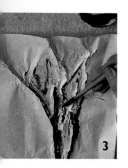

3 Fill in the trunks of the trees with burnt sienna. If the picture is sufficiently large you could also fill in some of the branches.

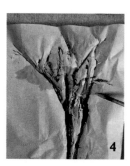

4 Add light green as required. Both Chinese mineral green or Teppachi light green would be suitable.

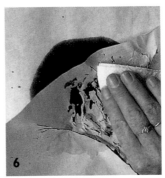

5 Cover a piece of paper with black ink. It is important to carry this out quickly before the ink has time to soak into the paper too much.

6 Blot your painting onto the wet ink (beware handprints!). Again, the level of "darkness" you include depends on the proposed atmosphere.

7 Add some black or dark blue ink on the back of the painting with a brush, especially behind some of the light green.

8 Add any dark, dry strokes that you consider necessary to contrast with the rest. You should now have a good look at the painting to see if any figures or other detail need to be added. Pin the painting up somewhere and stand back to see it from a distance. This advice applies to all your paintings.

9 The completed painting. An atmosphere of coolness, mystery, and dark recesses has resulted from the various stages. Calligraphy and seals can be added if desired.

Blotting Color

You can transfer color easily from one piece of paper to another, in fact
this often happens when you do not want it to!

You can transfer color easily from one
piece of paper to another; in fact, this
often happens when you do not want it
to! To achieve the effects in the example
by Qu Lei Lei below, paint the required
shape onto a spare piece of paper,
place the painting on top and press
down evenly, making sure not to
transfer handprints as well. With some
imagination you can
produce some really
exciting effects. Try not to
set out with a particular
theme or result in mind,
but play with the paper and
paint, hesitating occasionally,
even letting it all dry and
hanging it up for a few
days, before beginning the
next stage. If you wish the
paint and ink to blend, you
may need to dampen the
painting with clean water
before proceeding.

With all these techniques, the
Xuan and *Yuan shu* papers give good
results, but practice papers can be
used, provided more care is taken in
handling them as they may disintegrate
more easily.

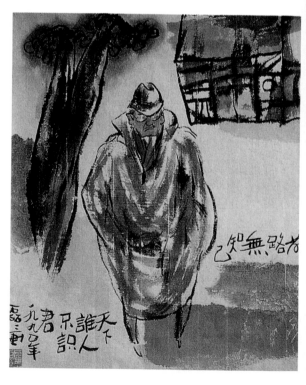

RIGHT *This painting by Qu Lei
Lei on Yuan shu paper is taken
from his* English Life *series of
paintings and uses a blotting
technique on the house and
ground. The tree is painted both
from in front and behind.*

Running Ink

There are several examples of work by Dai Ying throughout this book that illustrate the running ink technique. The aim is to use wet ink and to add color and/or water before the wet ink has dried. This forces the ink and color to run into the paper.

This method works well on thicker papers where the ink takes longer to dry. It is also effective when color is placed between two lines or within a flower shape. The ink is then pushed in one direction only and the inner edge of the line remains clean. Controlling the amount of ink and using thick paper will enable you to persuade the ink to travel quite a distance.

To paint the apricot blossom, first mix burnt sienna with water in the palette, followed by light green or pink. Put in the two outline strokes for the branch with black ink. Work quickly and with a brush that is not too small. Immediately run a wet brush of burnt sienna down the center of the stem. If this is not enough, add some water as well. When you feel the ink has traveled far enough blot with a tissue. If the ink does not flow far enough, try using more ink or work in smaller sections.

The flowers are painted individually, again taking care not to use too small a brush or the ink will dry too quickly. In this case add extra water. To provide contrast with the wet technique, the stamens are added last with very black ink, when the color and ink are dry.

ABOVE *This spring blossom is painted in the style favored by Dai Ying. The seal says, "apricot blossoms in the spring rain" and it provided the inspiration for this painting.*

RIGHT *These trees, painted using the running-Ink technique, are a contemporary shape and will not appeal to everyone. There are many subjects that could be explored using a combination of different techniques and styles.*

GLOSSARY

Terms used in Chinese Brush Painting

bai miao traditional ink and brush line drawing

bifa brush techniques

bimo ink and brush techniques

calligraphy fine writing

cefeng side brush

cinnabar a bright red mineral derived from mercury sulphide

colophon an inscription—postscript, poems, or comments—appended to a finished painting or its mounting

cun texture stroke

dao the way

dian dotting technique used to enhance shapes and space

fei bai flashing white

fupi ax cuts

gongbi fine brush painting

gou outline drawing with a brush

jie bamboo joint

jie hua drawing with a ruler

mi character for rice

mo ink stick

mofa ink techniques

mogu without bone

pima stranded hemp

pobi split brush

pomo splashed ink

qi spirit

ran faint coloring and shading

seal an impression made from carved stones or other media presssed into a thick, red, oil-based paste

shuang gou drawing on both side's

tuobi dragged brush

xiao pin simple style (artistic creation)

xieyi free brush painting

xuanzhi rice paper

yan inkstone

yin and yang an ancient, fundamental concept that describes the underlying nature and order within the universe

yun charm; good taste

zhi paper

zhongfeng center brush

zhuanbi turning brush

CHINESE DYNASTIES

The Chinese were ruled by various dynasties – a time period that is ruled by a specific family. The following are dynasties that are mentioned in the text of this book.

SHANG DYNASTY: 1700–1027 B.C.E.

The Shang Dynasty (also called the Yin dynasty in its later stages) is believed to have been founded by a rebel leader who overthrew the last Xia ruler. Its civilization was based on agriculture, augmented by hunting and animal husbandry. Two important events of the period were the development of a writing system, as revealed in archaic Chinese inscriptions found on tortoiseshells and flat cattle bones (commonly called oracle bones), and the use of bronze metallurgy.

HAN DYNASTY:
206 B.C.E.–220 C.E.

The Han Dynasty, after which the members of the ethnic majority in China, the "people of Han," are named, was notable also for its military prowess. The empire expanded westward as far as the rim of the Tarim Basin (in modern Xinjiang-Uyghur Autonomous Region), making possible relatively secure caravan traffic across Central Asia to Antioch, Baghdad, and Alexandria.

TANG DYNASTY: 618–907 C.E.

The Tang Dynasty, with its capital at Chang'an, is regarded by historians as a high point in Chinese civilization, equal, or even superior, to the Han period. Its territory, acquired through the military exploits of its early rulers, was greater than that of the Han.

SONG DYNASTY: 960 C.E.

A military leader, Chao K'uang Yin, seized power and proclaimed the Song Dynasty. Within a few years he and his officials had restored peace. The Song were wiser than the other dynasties because they knew how the other dynasties had fallen when the governors became too powerful; instead, they did not split up the land into sections. China was under the emperor's hands only. They reestablished Confucianism as the master philosophy and reunified most of China Proper. The Song dynasty can be divided into two periods: the Northern Song and Southern Song. The Northern Song (960-1127 C.E.) refers to the time when the Song capital was in the northern city of Kaifeng and the dynasty controlled all China. The Southern Song (1127-1279 C.E.) is the time after the Song lost control of northern China.

MING DYNASTY: 1368–1644 C.E.

Yu-chang founded the Ming Dynasty in 1368 and in 1371 he drove the Mongols out of Beijing. After more than a century of ruling, the Mongolians retreated to the Mongolian heartland. The Mings were less inventive than the past dynasties because this was a trading period between the European neighbors.

QING DYNASTY:
1644–1911 C.E.

The Manchus had reached their power in the 18th century when they controlled Manchuria, Mongolia, and Tibet. Also, Chinese influence had reached Nepal, Burma, Korea, and Vietnam. During the last decades of the 19th century foreign governments gained control over parts of China. Revolutionary leader Dr. Sun Yat-Sen succeeded in toppling this, the last, Chinese Dynasty.

INDEX